THAMES & MEDWAY
PLEASURE STEAMERS
FROM 1935

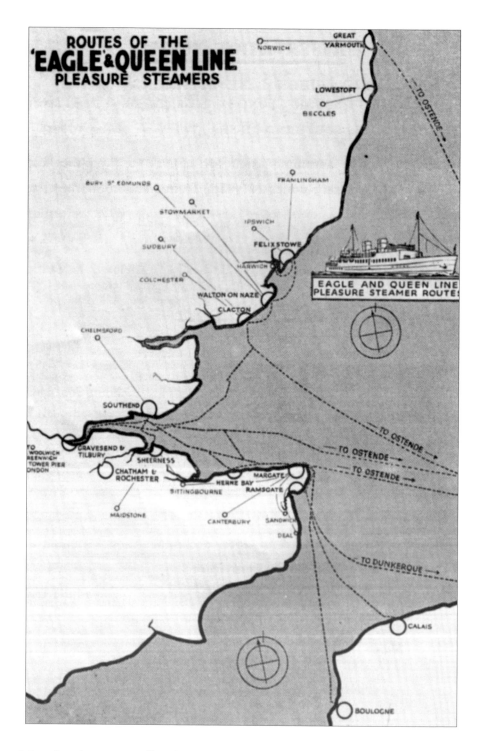

Map showing routes offered by 'Eagle and Queen Line Steamers' dating from 1938. Less than thirty years later all of these services had ceased.

THAMES & MEDWAY PLEASURE STEAMERS FROM 1935

ANDREW GLADWELL

AMBERLEY

To find out more about Pleasure Steamer Heritage: www.heritagesteamers.co.uk

To book a cruise on *Waverley* or *Balmoral*: www.waverleyexcursions.co.uk

To book a cruise on *Kingswear Castle*: www.kingswearcastle.co.uk

To join the PSPS: www.paddlesteamers.org

First published 2009

Amberley Publishing Plc
Cirencester Road, Chalford,
Stroud, Gloucestershire, GL6 8PE

www.amberley-books.com

Copyright © Andrew Gladwell 2009

The right of Andrew Gladwell to be identified as the
Author of this work has been asserted in accordance
with the Copyrights, Designs and Patents Act 1988.

ISBN 978 1 84868 694 6

British Library Cataloguing in Publication Data.
A catalogue record for this book is available from
the British Library.

Typeset in Sabon.
Typesetting and Origination by DIAGRAF.
Printed in the UK.

Contents

Acknowledgements

In compiling this book, I have appreciated the generosity of the individuals below who have given so much of their time, memories and material to ensure that the heritage of Thames and Medway pleasure steamers is preserved. Some of the material in this book comes from the Paddle Steamer Preservation Society Collection www.heritagesteamers.co.uk and is being shown here for the first time. The PSPS Collection is the UK's largest and most important collection of paddle and pleasure steamer material. It provides a permanent and accessible home for unique material such as photographs, handbills, models, fittings and posters that are so intertwined with the memories included in this book. My appreciation goes to Myra Allen, Martin Longhurst and the PSPS for investing resources to ensure that this hugely important maritime collection survives for future generations to appreciate, use and enjoy. Many people have been generous with their time and material and I would like to thank Kieran McCarthy, Jean Spells and William Webb for their support with this project. I would like to say a very special thank-you to John Richardson MBE and Roy Asher for their great enthusiasm and for allowing me to use their unique material that captures so vividly the great days of the 'Eagle Steamers'. To all of these individuals I extend my thanks.

This book is dedicated to my grandfather George Williams who loved the GSN motor pleasure steamers and who frequently travelled on them for happy days at the seaside.

Introduction

If you mention the subject of pleasure steamers on the rivers Thames and Medway, you can be certain that most people will remember with fond nostalgia the well-loved steamers *Royal Daffodil*, *Royal Sovereign* and *Queen of the Channel*. Even now, well over forty years since their untimely demise, their fame and public affection for them is just as strong as it was in their heyday. They were simply the poor man's ocean liner. This book takes a long and nostalgic glance back to their short but eventful careers. It also looks at the context in which they were built as well as looking briefly at the other paddle steamers that were around from the early 1920s. Finally it looks to the twenty-first century and the steamers that carry on the great tradition. It is a view of the final golden years of Thames and Medway pleasure steamers: their decline and resurrection.

The 1930s were the golden age of the seaside holiday when people escaped the gloom of the depression and the storm clouds of impending war by escaping to the seaside. Modes of transport for most people had changed very little in around one hundred years with most using railways or ships to convey them for recreation to the vast fit-for-purpose and exciting resorts of the Kent and Essex coasts. The pleasure steamer by its very name, was built for pleasure and the venerable General Steam Navigation Company reigned supreme on London's great river. Founded in 1824, 'Eagle Steamers' provided the ultimate in service, quality and comfort. On the Medway, the New Medway Steam Packet Company offered similar standards albeit on a more modest scale. Both offered a range of traditional paddle steamers with the *Medway Queen* (1924) and *Royal Eagle* (1934) being amongst the newest additions to the fleets. But, tastes and expectations were changing fast.

By the early 1920s, things had began to change with the arrival of Captain Sydney Shippick on the River Medway and the newly-formed New Medway Steam Packet Company. With an insatiable appetite for increasing business, he embarked upon an era of expansion that culminated in the mid-1930s building of three splendid new motor vessels. In an era immortalised in the Art Deco style, a new breed of Thames Estuary greyhound was yearned for to encompass the modern age and that curious and unexplained mix of people, needs and finance came together to build arguably the finest pleasure steamers ever built for service in the UK. Sydney Shippick had created something quite wonderful and new!

Queen of the Channel (1935), *Royal Sovereign* (1937) and *Royal Daffofil* (1939) with their sleek lines and luxurious and ample accommodation soon made them the envy of other pleasure steamer operators around the UK. It looked like they were set for remarkable and long careers on the London River and further field to the continent. But alas, the Second World War took it toll and despite gallant wartime service, only the *Royal Daffodil* returned to take-up the happy role for which she had been built. After six years of wartime service she swapped troops for happy holidaymakers eager to spend a carefree day in Southend or Margate after years of fear and uncertainty. But the 'People's War' had changed many things and the aspirations and needs of post-war society was unlike that of the previous generation. The venerable General Steam Navigation Company pressed on with confidence and arrogance in building two fine

pleasure steamers to replace their wartime losses. The Denny of Dumbarton-built *Royal Sovereign* (1948) and *Queen of the Channel* (1949) promptly joined the *Royal Daffodil* in proudly flying the GSNC flag to re-commence services from where life was so rudely interrupted in 1939.

What started as subtle and maybe temporary changes in taste and habits in the late 1940s had by the late 1950s become permanent changes. The motor car made transport more personal and flexible. Soon the delights of foreign holidays with their unlimited sun and modern amusements became a preferred option to a week of rain in Margate. Younger people found their own music and a lifestyle miles away from that of their parents. For them, in a world reflected in the world of 'rock and roll', the somewhat static world of the pleasure steamer was out of touch with their needs. In some respects, Eagle Steamers reacted to these new needs by introducing more cross-Channel cruises as well as rock and jazz cruises. Older paddle steamers were withdrawn and a more slender and modern fleet emerged. The 1960s was though the age where no respect was given to heritage. The Paddle Steamer Preservation Society was formed in 1959 to try and halt the decline. But, by that time it was too late and the trickle of pleasure steamers being withdrawn soon became a horrible deluge. Nobody could do anything. A few days before Christmas in December 1966, the once untouchable General Steam Navigation Company announced the cessation of pleasure steamer cruises on the River Thames – an unthinkable scenario just a generation earlier. It was a moment in time when people were left almost speechless by the severity and speed of the end.

Since that time, those three splendid post-war pleasure steamers have never been forgotten. In an age where heritage is important, they are remembered with great nostalgia by people who travelled aboard them regularly – as well as those who never had that pleasure, but yearn for the style and romance of travel in a different age. Most readers will have a different reason for buying a book about the post-war Thames and Medway pleasure steamer fleet – all will though be reminded of the style, confidence and different pace of life reflected in the *Royal Daffodil*, *Royal Sovereign* and *Queen of the Channel*. We must also always keep in mind how important it is to protect the precious maritime heritage that we have, to never become complacent and to always learn from the experiences of the past.

How lucky we are then to have three pleasure steamers that regularly ply the Thames and Medway each year. The immaculate and charming *Kingswear Castle* is now proudly the only regular paddle steamer on the Thames and Medway and has now spent over twenty five years paddling in the area thereby beating the careers of many Thames pleasure steamers such as the *Royal Eagle*, *Royal Daffodil* and *Crested Eagle*. The *Balmoral* is also a regular visitor to the Thames each summer offering a wide range of cruises covering the old routes of the Eagle Steamers and is the last of the great motor pleasure steamers. Lastly, the majestic and atmospheric *Waverley*, now the last sea-going paddle steamer in the world, graces the Thames and Medway with a fine selection of cruises each autumn.

This book is not meant to be an exhaustive history of Thames pleasure steamers from 1935, but is a nostalgic look back at the most fondly-loved pleasure steamers and especially the five 'Eagle & Queen Line' motor ships. It is a book as much about people whether they spent many hours on a carefree cruise to the coast or worked aboard one of the ships. People bring alive the steel and timber of pleasure steamers. This book is about memories and aren't we lucky in that we are still able to create memories through the pleasure steamers of the twenty-first century; *Waverley*, *Kingswear Castle* and *Balmoral*!

Chapter 1

The Old and the New

The 1930s ushered in a new modern way of life in the UK for many. In an era defined by sleek modernistic buildings, fashion and design, would the traditional and slow evolving paddle steamer change to reflect this new age?

By the late 1920s, Captain Sydney Shippick was firmly at the helm of the New Medway Steam Packet Company. He had initiated expansion in the mid-1920s with the *Medway Queen* and the new marketing banner 'Queen Line of Steamers' and his 'navy' soon began to dominate the excursion business. Despite the Great Depression, the 1930s saw cheery Londoners continue to flock to the coast by pleasure steamer. 1932 saw General Steam Navigation introduce the splendid and distinctive new *Royal Eagle* – the last ever Thames paddle steamer to be built.

But by the mid-1930s however, thoughts were diverting towards the use of diesel screw propulsion over that of the more traditional paddle wheel. Shippick yearned to expand and operate steamer services to the continent and the opportunity that the diesel engine offered for fast services to France was too much for Shippick to resist.

In 1935, Captain Sydney Shippick took the plunge and the New Medway Steam Packet Company worked in collaboration with the prestige shipbuilders William Denny of Dumbarton to construct the ground-breaking *Queen of the Channel*. She was a ship built for purpose; that of a cross channel greyhound. The gamble made by Sydney soon paid off as she entered service to universal acclaim. Her motive power wasn't her only novel feature. Her interior was spectacularly stylish and different to that seen before on the London River. Internal spaces were looked at differently and it was also clear that the needs of the passenger were foremost in Shippick's thoughts. The provision of ample covered as well as outdoor accommodation was integral to the new design. The success of the *Queen of the Channel* was confirmed by the commissioning of two similar motor ships – the *Royal Sovereign* of 1937 and the legendary and most popular of all Thames pleasure steamers, the *Royal Daffodil* of 1939. Competition between the General Steam Navigation Company and the New Medway Steam Packet Company reached a climax in the late 1930s when a merger was agreed and the new and pleasantly named 'Eagle & Queen Line Steamers' was born.

But by the time of the entry into service of the *Royal Daffodil*, the storm clouds of the Second World War were casting a gloomy shadow over this splendid new fleet of three pleasure steamers. As the Second World War rudely interrupted Sydney Shippick's grandiose plans, but the fleet of Thames and Medway pleasure steamers experienced one of their finest moments as they evacuated over 20,000 children from London and surrounding counties to the relative safety of the Norfolk and Suffolk coast. It would be six long years before the daytrippers would return and by that time, much of the fleet would be gone.

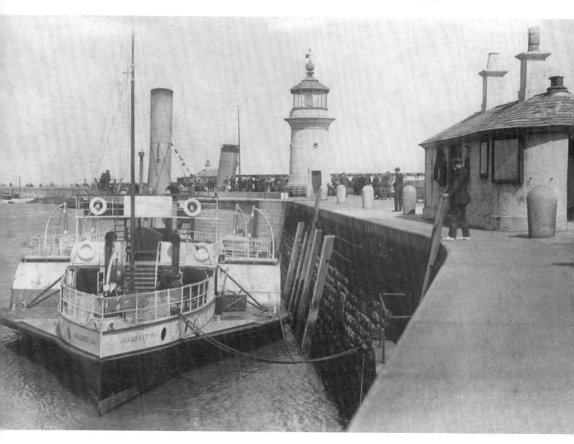

The *Audrey* at Ramsgate in 1929. *Audrey* was acquired by Captain Sydney Shippick in 1914 and they both took up work for the Admiralty at Sheerness at the outbreak of hostilities. Firmly established on the Medway after the end of the war, Shippick set up the New Medway Steam Packet Company to acquire the assets of the old Medway Steam Packet Company. Within a few short years, the company had grown dramatically due to his shrewd business acumen.

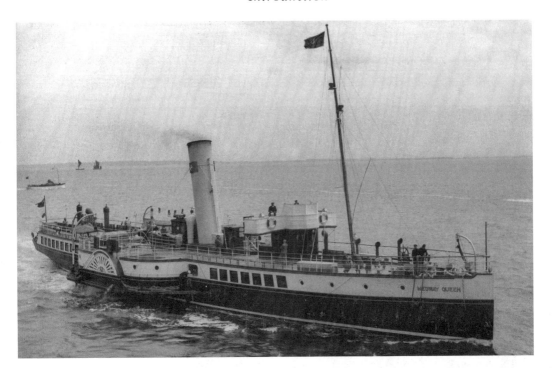

Medway Queen was built in the year that the term 'Queen Line of Steamers' was first used and was the first 'Queen' to be built. She was always associated with the service from the Medway towns to Southend and Herne Bay and is pictured here in her heyday about to arrive at Southend Pier.

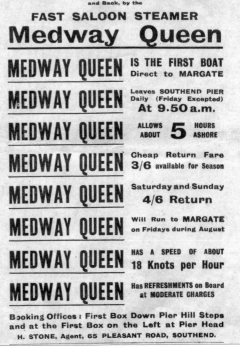

New Medway Steam Packet Co., Ltd.

CHEAP TRIP TO MARGATE

and Back, by the

FAST SALOON STEAMER

Medway Queen

MEDWAY QUEEN	IS THE FIRST BOAT Direct to MARGATE
MEDWAY QUEEN	Leaves SOUTHEND PIER Daily (Friday Excepted) At 9.50 a.m.
MEDWAY QUEEN	ALLOWS ABOUT **5** HOURS ASHORE
MEDWAY QUEEN	Cheap Return Fare 3/6 available for Season
MEDWAY QUEEN	Saturday and Sunday 4/6 Return
MEDWAY QUEEN	Will Run to MARGATE on Fridays during August
MEDWAY QUEEN	HAS A SPEED OF ABOUT 18 Knots per Hour
MEDWAY QUEEN	Has REFRESHMENTS on Board at MODERATE CHARGES

Booking Offices : First Box Down Pier Hill Steps and at the First Box on the Left at Pier Head
H. STONE, Agent, 65 PLEASANT ROAD, SOUTHEND.

A very early 1920s handbill for the *Medway Queen* advertising trips from Southend to Margate. *Medway Queen* was lucky in having only two masters during her career. Captain Hayman from the 1920s and then Captain Leonard Horsham from 1947 until her final trip in 1963 after which he joined the GSNC cargo fleet. Leonard Horsham died shortly afterwards at the young age of fifty-seven.

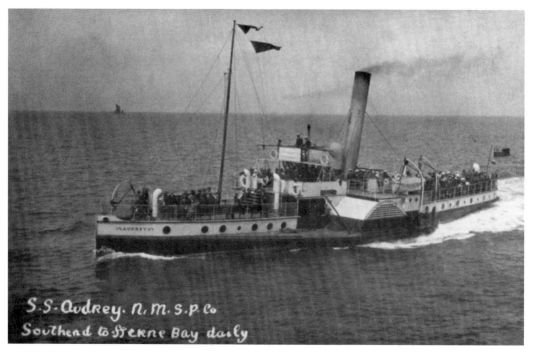

S.S. Audrey. N.M.S.P.Co
Southend to Herne Bay daily

The little paddle steamer *Audrey* can be seen as the first of the large and important fleet that culminated in the building of the giant and ultra-modern diesel motor vessel *Queen of the Channel* in 1935, swiftly followed by the *Royal Sovereign* in 1937 and the *Royal Daffodil* in 1939. Captain Tommy Aldis took command of *Audrey* and worked in partnership with Sydney Shippick to expand the NMSPC fleet.

In 1924 Sydney Shippick had the *Medway Queen* built, followed closely by the acquisition of two Ascot-Class Paddle Minesweepers *Queen of Kent* and *Queen of Thanet*. Cruises by them are advertised on this handbill. Soon, other vessels joined the ever expanding fleet including the *Queen of Southend* in 1928, *Rochester Queen* in 1932, *Clacton Queen* in 1933 and the *Royal Daffodil* (I) in 1934.

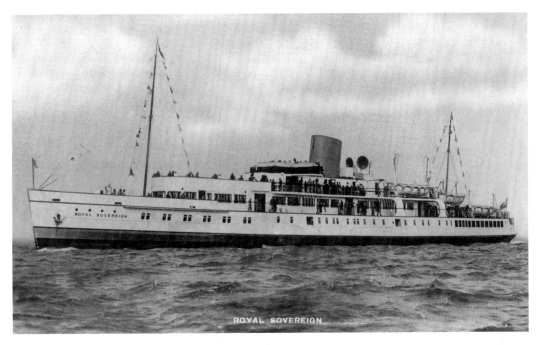

A splendid-looking *Royal Sovereign* soon after her entry into service.

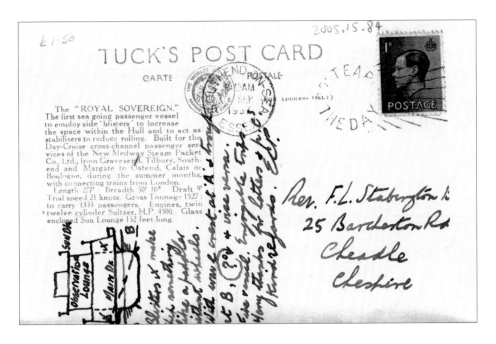

The reverse side of postcards often tell us an awful lot more than the front. This is the reverse of the postcard shown above. It explains, with a small diagram and notes, the effect that the side blisters had in making the new motor vessels just like a paddle steamer. The postcard is believed to have been sent by Thames and South Coast pleasure steamer historian Edward Thornton.

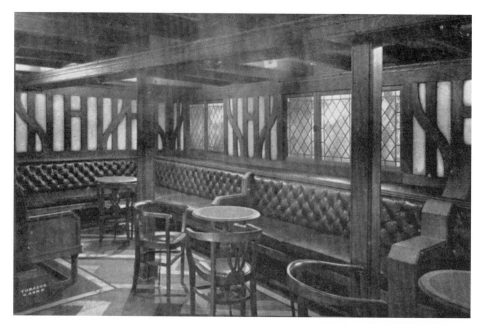

Part of one of the special Cocktail Lounges aboard the *Queen of the Channel*. It shows the strong style of the new vessel although the 'Tudorbethan' décor was rather at odds with the sleek Art Deco lines of the vessel. Note the large cigarette ash cans in this image and others – a feature that wouldn't be required in the twenty-first century.

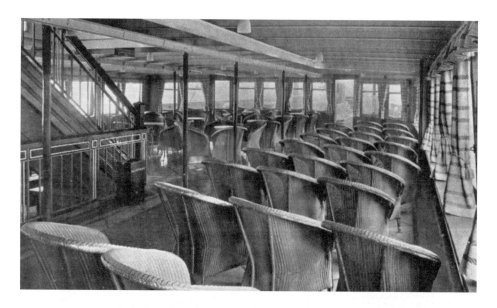

Part of the Observation Lounge aboard the *Queen of the Channel*. Note the obligatory Lloyd Loom armchairs and the subtle but stylish handrails, fabrics and linoleum. *Queen of the Channel* was said to have 'palatial' accommodation that included buffets, cocktail bars, private cabins and saloons.

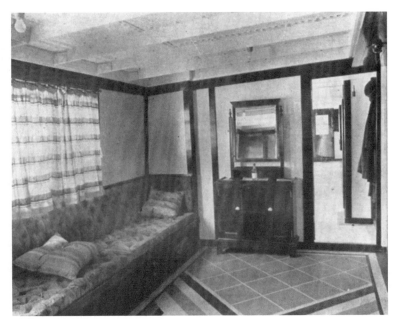

A corner of the Ladies Room aboard the *Queen of the Channel*. It is typical of the sort of facility that wouldn't be required these days but was much-needed in the late 1930s. Note the patterned linoleum that was always a feature of such vessels during the 1930s and into the 1940s. *Waverley*'s new dining saloon and other saloons featured patterned linoleum when built in 1946-47.

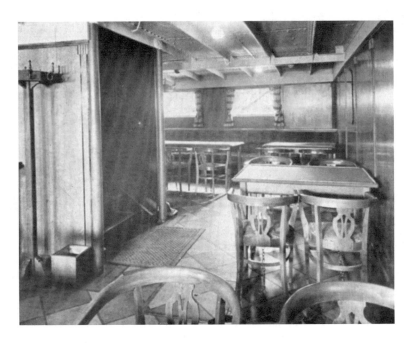

A stairway and saloon aboard the *Queen of the Channel*.

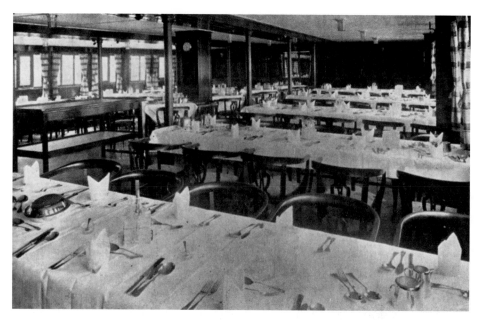

Part of the palatial Aft Dining Saloon aboard the *Queen of the Channel*. Dining was organised with military precision. Diners had to consume their meals quickly in order that tables could be cleared and set for those that followed. In addition to the main dining saloons, the *Queen of the Channel* included private dining rooms for the use of private parties and family groups.

Cover from a pocket-size programme outlining services to Calais and Ostend from Clacton, Felixstowe and Walton during the 1939 season by the 'Eagle & Queen Line'. It outlines the heritage and tourist attractions of both destinations. Special coach and train tours were also offered to steamer passengers.

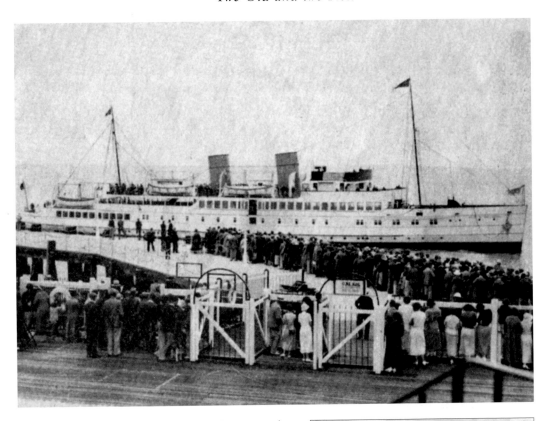

Passengers queuing on Clacton Pier in 1938 ready to board the *Queen of the Channel*. Note the orderly queues and the gates with embarkation details to ensure that passenger transfers were speedy and efficient.

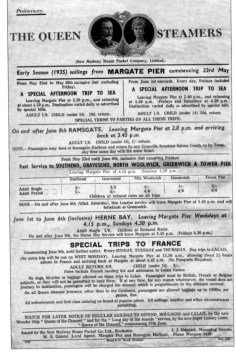

Handbill for 'Queen Line' steamer services from Margate during the Silver Jubilee year of George V and Queen Mary in 1935. Many of the handbills during that season carried banner images of King George and Queen Mary. It notes that a later handbill would include services by the new 'Wonder Ship' *Queen of the Channel* to Boulogne, Calais and Ostend from 29 June.

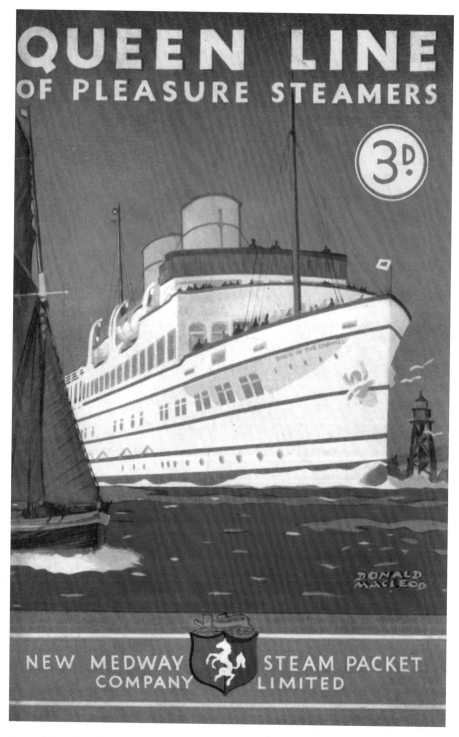

Souvenir brochure for the 'Queen Line of Pleasure Steamers' published in 1937. It shows a striking image of the new and mighty *Queen of the Channel*.

EAGLE & QUEEN LINE PLEASURE STEAMERS

A Glorious Opportunity
On TUESDAY, ~~JUNE 28th~~ July 19th
To Witness the Crossing of Their Majesties
KING GEORGE VI and QUEEN ELIZABETH
In the Admiralty Yacht H.M.S. "Enchantress," escorted by Warships, on the occasion of their
FIRST STATE VISIT TO FRANCE

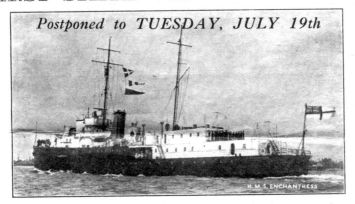

Postponed to TUESDAY, JULY 19th

H.M.S. ENCHANTRESS

For this unique occasion the following Programme has been arranged:

M.V. "ROYAL SOVEREIGN"
(weather and other circumstances permitting)

will leave Margate Jetty at 10.0 a.m., pick up Escort off Dover at 11.15 a.m., proceed with Fleet to off Boulogne Harbour, witness Their Majesties' Ship proceed into Harbour, then leave for Calais where about three hours on shore is allowed, leave Calais 5.0 p.m., arrive back at Margate 7.0 p.m.

Usual Calais Fare: Adult 9/-; Children 5/-
Including Special Coach Tour through Forest of Guines and Calais Town: Adult 11/6; Child 6/6

SPECIAL NOTE—A large French Naval Force of modern ships will escort Their Majesties from Dover to Boulogne and include: Battleship—"Dunkerque"; Cruisers—"Georges Leygues," "Gloire" and "Montcalm"; Destroyers—"Le Terrible," "Le Fantasque" "L'Audacieux" and "Bison"; Three Divisions of Torpedo Boats, and a Flotilla of Submarines.

● **Do not miss this Magnificent Sight** ●

Book at THE JETTY, MARGATE.　　　**Phones: 398 or 1430**

★ Day Return Tickets only. No Passports required. First-Class Catering and Refreshments at Popular Prices. Fully Licensed ★
Passengers are only carried on the terms and conditions printed on the Company's Tickets.

IMPORTANT NOTICE
Passengers to Boulogne, Ostende, Dunkerque or Calais must be British, French or Belgian subjects or they will not be permitted to land there Passengers having gone ashore will not be allowed on board again until half-an-hour before advertised time of sailing. No luggage, dogs or bicycles allowed on these trips. Coastwise passengers are also restricted to these regulations and their luggage subject to Customs' examination if required. Continental fares include landing tax.

H. J. TOBY, Printer, Margate.

Handbill advertising a cruise on the *Royal Sovereign* to witness the newly-crowned King George VI and Queen Elizabeth travelling on their first state visit to France aboard HMS *Enchantress* on Tuesday 19 July 1938. At a time of political turmoil the visit was intended to reinvigorate the entente cordiale and to reinforce Anglo-French solidarity against Hitler's Germany. It also saw the emergence of the 'white wardrobe' of Queen Elizabeth by Hartnell and her unique style.

Queen of the Channel (left) with *Royal Sovereign* (right) berthed at Ostend on 14 August 1937. A shot summing up Sydney Shippick's vision of a continental pleasure steamer service – a world away from taking passengers to Southend and Margate of a decade earlier.

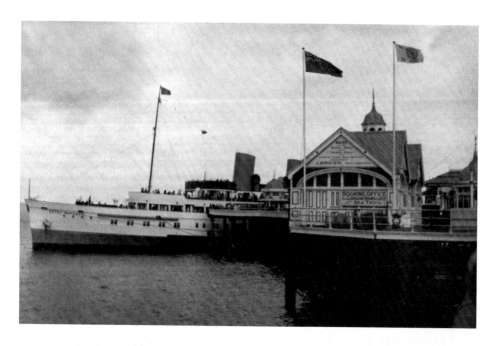

Royal Daffodil alongside Margate Pier during her first few months of service in 1939. Margate was one of the most popular destinations for 'Eagle Steamer' passengers. In 1841 there were six companies trading to and from Margate but by the mid-1960s, services had declined so much that just GSN were operating from the resort.

'Eagle Steamers' wine list from 1937. At the time a bottle of fine champagne could be obtained for less than £1 and a bottle of beer for four pence.

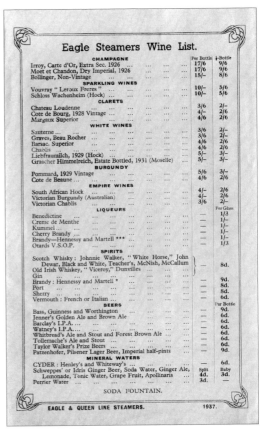

Eagle Steamers Wine List.

CHAMPAGNE	Per Bottle	½-Bottle
Irroy, Carte d'Or, Extra Sec. 1926	17/6	9/6
Moet et Chandon, Dry Imperial, 1926	17/6	9/6
Bollinger, Non-Vintage	15/-	8/6
SPARKLING WINES		
Vouvray " Leroux Freres "	10/-	5/6
Schloss Wachenheim (Hock)	10/-	5/6
CLARETS		
Chateau Loudenne	3/6	2/-
Cote de Bourg, 1928 Vintage	4/-	2/6
Margaux Superior	4/6	2/6
WHITE WINES		
Sauterne	3/6	2/-
Graves, Beau Rocher	3/6	2/-
Barsac. Superior	4/6	2/6
Chablis	5/-	3/-
Liebfraumilch, 1929 (Hock)	5/-	3/-
Gracher Himmelreich, Estate Bottled, 1931 (Moselle) ...	5/-	3/-
BURGUNDY		
Pommard, 1929 Vintage	5/6	3/-
Cote de Beaune	4/6	2/6
EMPIRE WINES		
South African Hock	4/-	2/6
Victorian Burgundy (Australian)	4/-	2/6
Victorian Chablis	3/6	2/-
LIQUEURS		Per Glass
Benedictine	—	1/3
Creme de Menthe	—	1/-
Kummel	—	1/-
Cherry Brandy	—	1/-
Brandy—Hennessy and Martell ***	—	1/-
Otards V.S.O.P.	—	1/3
SPIRITS		
Scotch Whisky : Johnnie Walker, " White Horse," John Dewar, Black and White, Teacher's, McNish, McCallum	}	8d.
Old Irish Whiskey, " Viceroy," Dunvilles		
Gin	—	9d.
Brandy : Hennessy and Martell *	—	9d.
Port	—	8d.
Sherry	—	8d.
Vermouth : French or Italian	—	6d.
BEERS		Per Bottle
Bass, Guinness and Worthington	—	9d.
Jenner's Golden Ale and Brown Ale	—	6d.
Barclay's I.P.A.	—	6d.
Watney's I.P.A.	—	6d.
Whitbread's Ale and Stout and Forest Brown Ale ...	—	6d.
Tollemache's Ale and Stout	—	6d.
Taylor Walker's Prize Beers	—	6d.
Patzenhofer, Pilsener Lager Beer, Imperial half-pints ...	—	9d.
MINERAL WATERS		
CYDER : Henley's and Whiteway's	—	6d.
Schweppes' or Idris Ginger Beer, Soda Water, Ginger Ale, Lemonade, Tonic Water, Grape Fruit, Apollinaris ...	Split 4d.	Baby 3d.
Perrier Water	3d.	—

SODA FOUNTAIN.

EAGLE & QUEEN LINE STEAMERS.　　　　1937.

Royal Sovereign berthed at Ostend with the *Queen of the Channel* behind her on 14 August 1937. Ostend was known at the time as the 'Queen of Watering Places' and was the summer residence of the Belgium royal family. It had many attractions to offer 'Eagle & Queen Line' passengers including golf, bathing, racing and, by night, the excitement of the Kursaal and casinos.

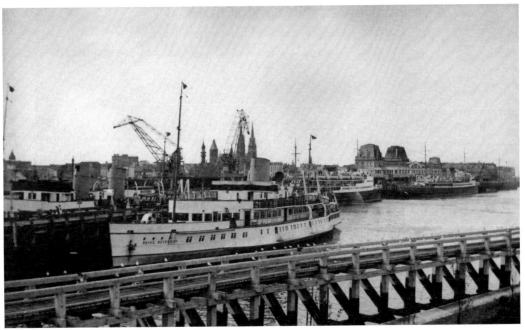

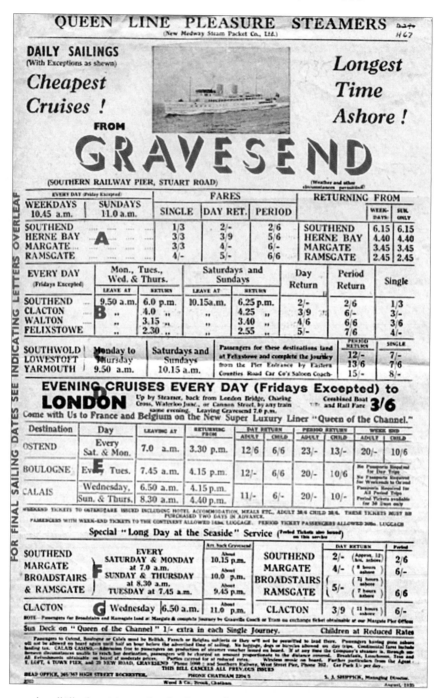

1935 handbill advertising cruises by the new luxury steamer *Queen of the Channel* from Gravesend. For many years the Gravesend agent was the well-known Mr Loft who had a shop in New Road and Town Pier Square. Final sailing dates during the 1935 season ranged from 14 to 23 September.

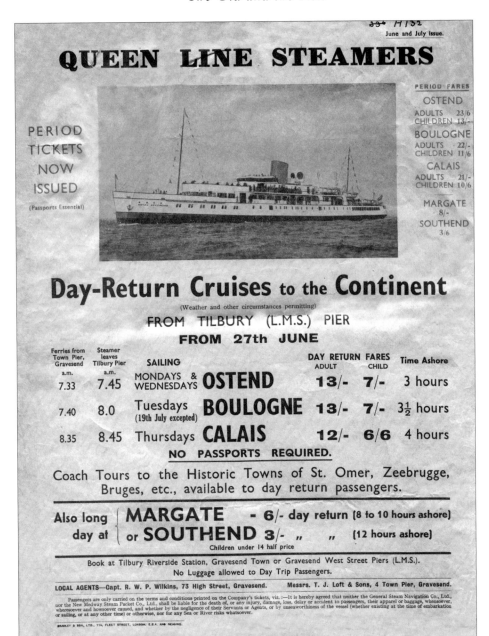

Handbill for cruises to Boulogne, Calais and Ostend by the *Royal Sovereign* during the 1938 season from Tilbury. Tours were popular with passengers once they disembarked in France. Many toured the First World War battlefields and cemeteries whilst others visited casinos, amusements and quaint old towns. Passengers who required the use of the Sun Deck aboard the *Royal Sovereign* paid an extra 2 shillings for the privilege.

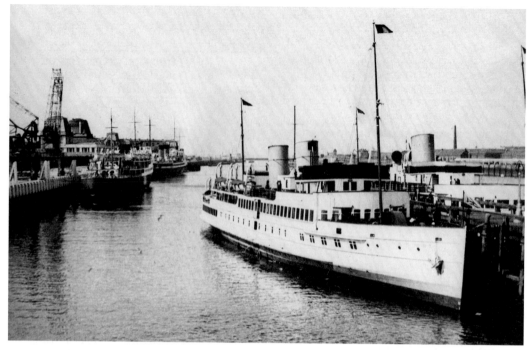

Queen of the Channel alongside Ostend in August 1937 with *Royal Sovereign* at the other side of the pier. *Royal Sovereign* operated from Gravesend to Ostend on Saturdays and Mondays during her first year in service. Belgium was advertised as the cheapest and most interesting place for a continental holiday. A full range of inclusive tours and holidays were offered to passengers. Destinations onwards from Ostend included Bruges, Rochefort, Dinant and Blankenberghe. In addition, short breaks were offered to see the First World War battlefields.

The first of the large motor ships for excursion services, *Queen of the Channel* entered service in 1935. She was originally owned by a separate company named 'The London & Southend Continental Shipping Company'. This was a consortium of Denny's of Dumbarton, who built her and the New Medway Steam Packet Company, who operated her. She was a handsome well-proportioned vessel but was in fact smaller than the *Royal Eagle*. Originally she was to be named *Continental Queen*.

Handbill for the *Queen of the Channel* from Margate during her first season in 1935. She could carry up to 1,600 passengers. *Queen of the Channel* had an enclosed promenade deck at the centre with an open boat deck above that was ideal in good weather. She looked similar to the Clyde turbine steamers because of this. She had two well-proportioned funnels with the forward one being a dummy.

QUEEN LINE STEAMERS

FIRST BOOKING OFFICE MARGATE PIER AND ON RIGHT AT PIER HEAD.

SPECIAL TRIPS from MARGATE PIER

Throughout the Season, from JUNE 22nd, 1935
(Weather and other circumstances permitting)

BY EUROPE'S LATEST SUPER-LUXURY LINER

"QUEEN OF THE CHANNEL"

(DIESEL-ENGINED TWIN-SCREW VESSEL) 1,100 TONS

TO

On Saturdays and Mondays **OSTEND** Leaving at 10.10 a.m.

Adult 10/6 Day Return Child (under 14) 5/6

On Tuesdays **BOULOGNE** Leaving at 10.45 a.m.

Adult 10/- Day Return Child (under 14) 5/6

On Sundays & Thursdays **CALAIS** Leaving at 11.30 a.m.

Adult 8/9 Day Return Child (under 14) 5/-

Allowing about 2½ hours in OSTEND	Arriving back at Margate from Ostend 7.0 p.m.
" 3 " " BOULOGNE	" " " " Boulogne 6.45 "
" 3½ " " CALAIS	" " " " Calais 6.45 "

NO PASSPORTS REQUIRED. SPECIAL TERMS TO PARTIES.

First-Class Catering and all Refreshments at Popular Prices.

DO NOT MISS THE OPPORTUNITY OF VISITING FRANCE AND BELGIUM BY THE FINEST VESSEL OF HER CLASS AFLOAT

THE LONDON & SOUTHEND CONTINENTAL SHIPPING Co., Ltd.,
in conjunction with
THE NEW MEDWAY STEAM PACKET CO., LTD.
W. S. GABRIEL (Agent) Margate & Ramsgate. Phone : Margate 1430

The Queen Line

IMPORTANT NOTICE.—Passengers to France and Belgium must be British, French or Belgian subjects or they will not be permitted to land there. Passengers having gone ashore are not allowed on board again until half an hour before the advertised time of sailing. No luggage, dogs or bicycles allowed on day trips to France or Belgium. Fares include Continental landing tax. If at any time, for any reason, the Company's vessel does not complete the journey to destination, passengers will be charged an amount proportionate to the distance covered. The charge for Sun Deck is 1/- extra each way.

NOTE — The time for passengers to re-embark for Return Journey is always announced on arrival at the Continental Port.

Head Office : 365-367 High Street, Rochester. Tel. Chatham 2204-5. S. J. SHIPPICK, Managing Director

Cooper, Printer, Margate

Royal Daffodil during her first season of operation at a continental port in 1939. The three sleek new motor ships enjoyed their only season working together in 1939 when in July and August they left from Tower Pier to the coast and continent.

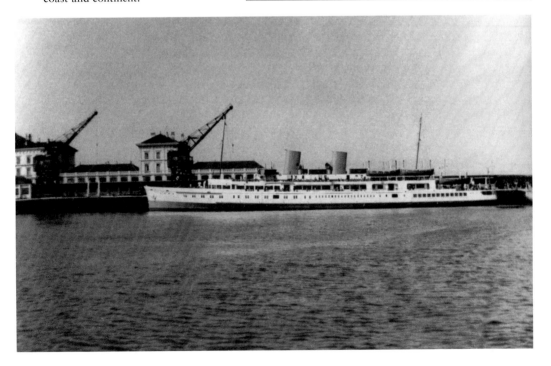

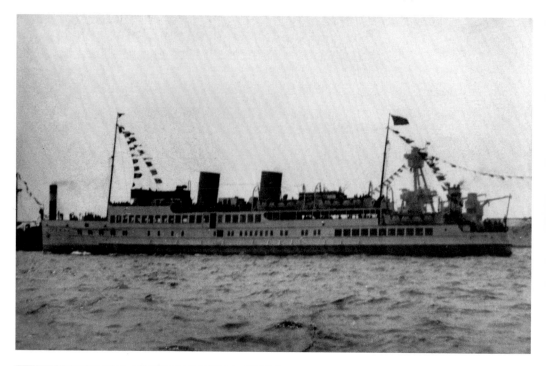

Queen of the Channel during the May 1937 Fleet Review at Spithead to mark the coronation of George VI and Queen Elizabeth.

The first *Queen of the Channel* approaching Southend Pier on 27 May 1939. She certainly was a fine looking pleasure steamer, especially with her two well-proportioned funnels and partly-enclosed Promenade Deck, as can be seen here.

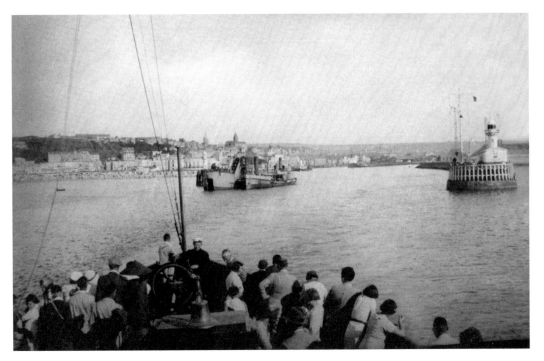

A view of the bow of the *Queen of the Channel* as she approaches the Boulogne pier heads in 1937.

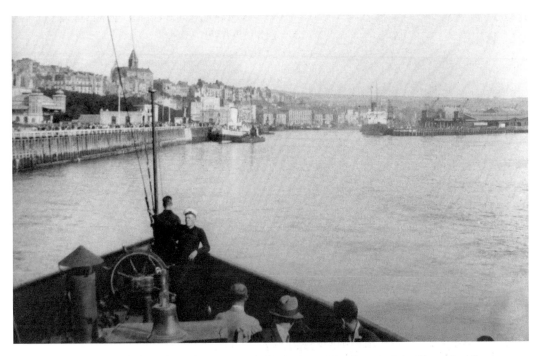

A view showing the bow from the Promenade Deck aboard the *Queen of the Channel* whilst approaching the harbour at Boulogne in 1937.

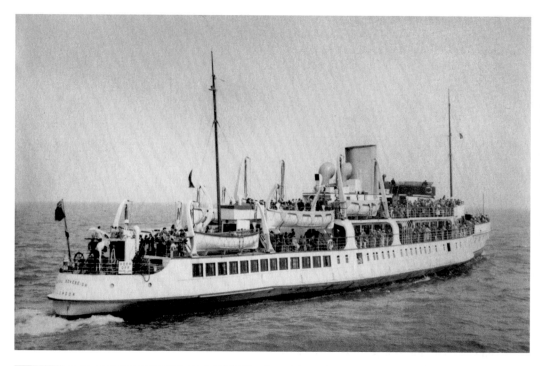

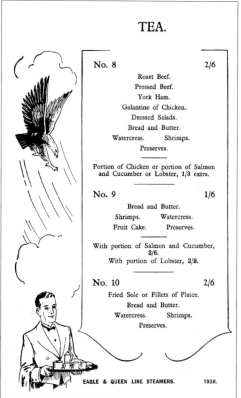

TEA.

No. 8	2/6

Roast Beef.
Pressed Beef.
York Ham.
Galantine of Chicken.
Dressed Salads.
Bread and Butter.
Watercress. Shrimps.
Preserves.

Portion of Chicken or portion of Salmon and Cucumber or Lobster, 1/3 extra.

No. 9	1/6

Bread and Butter.
Shrimps. Watercress.
Fruit Cake. Preserves.

With portion of Salmon and Cucumber, 2/6.
With portion of Lobster, 2/9.

No. 10	2/6

Fried Sole or Fillets of Plaice.
Bread and Butter.
Watercress. Shrimps.
Preserves.

EAGLE & QUEEN LINE STEAMERS. 1938.

Royal Sovereign was primarily built for the cross-channel day cruise market from Gravesend, Tilbury, Southend and Margate to Ostend, Boulogne or Calais. She was capable of carrying up to 1,333 passengers. Note the bulbous 'blisters' that flare out midships as well as the open Bridge.

Menu for three different types of high tea offered by Eagle & Queen Line Steamers to groups during the 1938 season.

Grill and cold buffet menu for 'Eagle & Queen Line Steamers' in 1938. Catering aboard the ships was extensive. It is astounding today to see the variety of food on the menu.

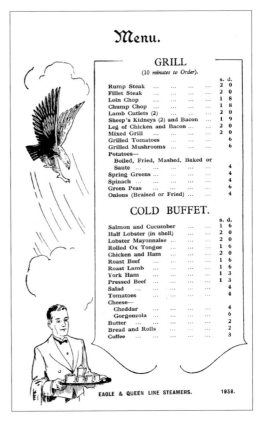

Menu.

GRILL
(10 minutes to Order).

	s.	d.
Rump Steak	2	0
Fillet Steak	2	0
Loin Chop	1	8
Chump Chop	1	8
Lamb Cutlets (2)	2	0
Sheep's Kidneys (2) and Bacon	1	9
Leg of Chicken and Bacon	2	0
Mixed Grill	2	0
Grilled Tomatoes		6
Grilled Mushrooms		6
Potatoes—		
Boiled, Fried, Mashed, Baked or Saute		4
Spring Greens		4
Spinach		4
Green Peas		6
Onions (Braised or Fried)		4

COLD BUFFET.

	s.	d.
Salmon and Cucumber	1	6
Half Lobster (in shell)	2	0
Lobster Mayonnaise	2	0
Rolled Ox Tongue	1	6
Chicken and Ham	2	0
Roast Beef	1	6
Roast Lamb	1	6
York Ham	1	3
Pressed Beef	1	3
Salad		4
Tomatoes		4
Cheese—		
Cheddar		4
Gorgonzola		6
Butter		2
Bread and Rolls		2
Coffee		3

EAGLE & QUEEN LINE STEAMERS. 1938.

The *Royal Sovereign* was built by Denny's of Dumbarton for the New Medway Steam Packet Company. Before her launch, GSN bought up the share capital of the New Medway Company. She was the first sea-going passenger vessel to have side 'blisters'.

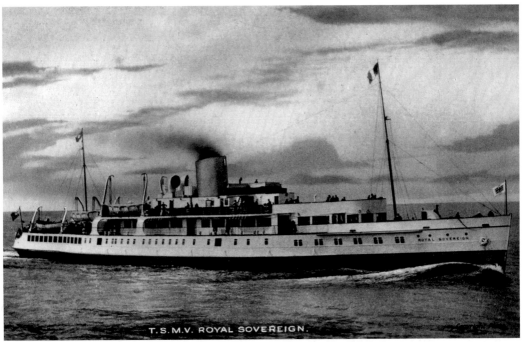

T.S.M.V. ROYAL SOVEREIGN.

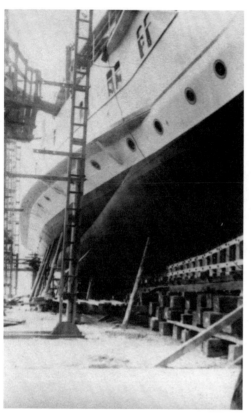

The wide decks on the three motor ships was the result of side 'blisters'. These enabled decks to flare and to offer larger saloons with more facilities as well as aiding stability in poor weather. This view taken whilst in dry dock shows a 'blister' well.

Royal Sovereign at sea in 1938. Her services from Gravesend offered for the first time a no-passport weekend service to Ostend. This included accommodation and steamer for just £1.75 – Sydney Shippick's dream had come to fruition. In addition to Ostend, she made calls at Boulogne and Calais.

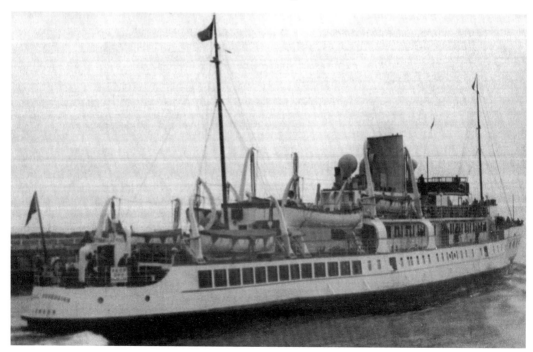

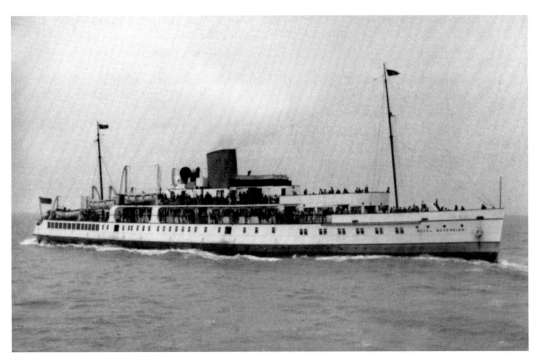

Royal Sovereign at sea around 1938. You can see from this photograph that *Royal Sovereign* had ample covered accommodation running most of the length of the ship as well as promenade space surrounding this. She was 269.5ft in length.

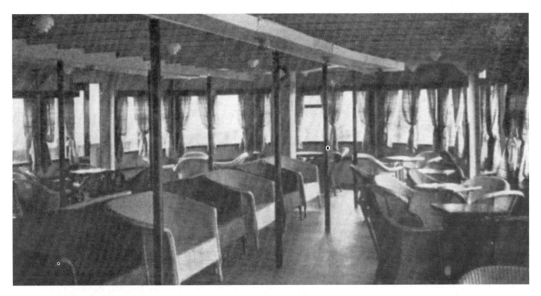

Part of the all-weather deck aboard the *Royal Sovereign* c.1938. The attractive Sun Lounge was over 150ft in length.

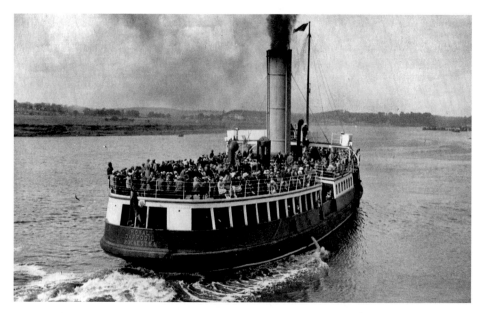

In 1933, the New Medway Company acquired the famous ferry *Royal Daffodil* from the Mersey. She had gained her 'Royal' prefix from her service at Zeebrugge during the First World War. Conversion work took place between 1933-34 and she took up the Medway to Southend service in 1934.

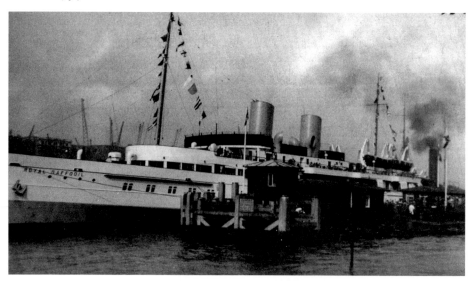

A resplendent *Royal Daffodil* in a special photograph showing her at Tower Pier, London on 27 May 1939. She is shown ready to embark upon her maiden voyage later that day. Just a few months later, in September, *Royal Daffodil* immediately began the task of evacuating over 4,000 women and children from the London area to Lowestoft and Great Yarmouth. Children weren't allowed to wander around the ship and deck games such as quoits and deck draughts were organised for the children. They were allowed to have a look around areas such as the pristine Engine Room under escort and many underprivileged children must have gazed in wonderment at such a treat.

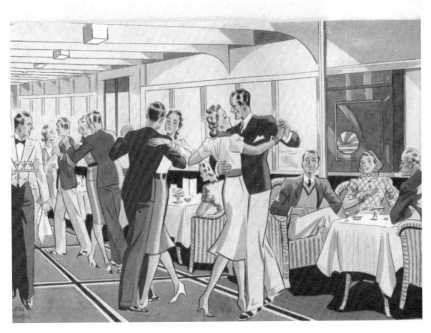

A Helen McKie painting showing dancing aboard the *Royal Daffodil* in 1939. GSN produced high quality marketing material and souvenir brochures that confirmed the quality and ambience of their pleasure steamers.

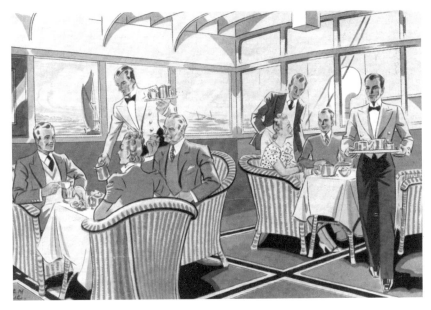

A Helen McKie painting showing afternoon tea being served in the covered lounge deck aboard the *Royal Daffodil* in 1939.

JUNE SAILINGS
from SOUTHEND — PIERHEAD to
FRANCE BELGIUM

		DAY RETURN FARES
At **10.0** a.m. arr. back at 9.0 p.m.	On *SUNDAYS, 11th, 18th & 25th JUNE & THURSDAYS, 8th, 15th 22nd & 29th By the Superb Twin-Screw Ships "ROYAL DAFFODIL" and "QUEEN OF THE CHANNEL"* TO **MARGATE** 4 Hrs. CRUISE and 7 Hrs. ASHORE AND **CALAIS** Abt. 5 Hrs. IN FRANCE and 8 Hrs. CRUISE	**MARGATE 5/-** **CALAIS 10/6**
At **8.45** a.m. arr. back at 10.30 p.m.	ON MONDAYS & WEDNESDAYS - "ROYAL DAFFODIL" TO **MARGATE** 4 Hrs. CRUISE and 10 Hrs. ASHORE AND **OSTEND** 10 Hrs. CRUISE and 5 Hrs. IN BELGIUM	**MARGATE 5/-** **OSTEND 12/-**
At **9.0** a.m. arr. back at 9.30 p.m.	ON TUESDAYS - "ROYAL DAFFODIL" TO **MARGATE** 4 Hrs. CRUISE and 8½ Hrs. ASHORE AND **BOULOGNE** 9 Hrs. CRUISE and 3½ Hrs. IN FRANCE	**MARGATE 5/-** **BOULOGNE 11/6**
AT **11.15** A.M. Returning from OSTEND 2 p.m. on Sunday, arr. S'end 7 p.m.	ON SATURDAYS - "ROYAL DAFFODIL" **DIRECT** TO **OSTEND** WEEK-END AND PERIOD TICKETS ONLY BY SATURDAY SAILING. COMBINED BOAT AND HOTEL BOOKINGS.	RETURN FARES Sat./Sun. 21/- Sat./Mon. 22/6 Period 25/- (Available till September)

FOR FULL INFORMATION OF TIMES, FARES, ETC., P.T.O.

BOOK on the PIER
or at EAGLE and QUEEN LINE STEAMERS, PIER HILL, SOUTHEND-ON-SEA
Phone : 67095

May, 1939 Borough Printing, & Publishing Co., 63a Southchurch Road, Southend-on-Sea.

Sailings from Southend Pier to Calais, Boulogne and Ostend during the 1939 season by *Queen of the Channel* and the *Royal Daffodil* in her inaugural season. It took on average five hours to reach Ostend from Southend at a cost of 21 shillings. Special inclusive weekend tours of the First World War battlefields were also offered for £3.

"Eagle" and Queen Line Pleasure Steamers

CONTINENTAL PROGRAMME

M.V. "Queen of the Channel"

EVERY SUNDAY TO

10 Hours Cruising OSTEND 3 Hours Ashore

(Weather and other circumstances permitting).

Clacton Pier . . . 9.30 a.m.

Arriving back at Clacton at 10 p.m.

Return 10/6 Fare

Book at Pier Entrance or 8 Electric Parade, Clacton-on-Sea No Passports Book in Advance
Service Buses connect with Steamers morning and night

Advertisement for cruises aboard the *Queen of the Channel* from Clacton to Ostend during the 1939 season. Sadly this was to be the final season for this steamer as she was lost during the war that started in September of that year. *Queen of the Channel* lifted 950 troops from Dunkirk on her single visit on 28 May 1940. After departing, she was attacked by Stukas and the bombs lifted her out of the water and she broke her back. Before she sank, her troops were transferred to another vessel.

Cover for brochure 'The Thames and all That'. It gives a full description of the heritage of the River Thames for passengers as well as up to date news of the steamers in the fleet. Once again, it shows Helen McKie illustrations of Thames pleasure steamers and passengers from the mid nineteenth century as well as photographic views from the 1930s.

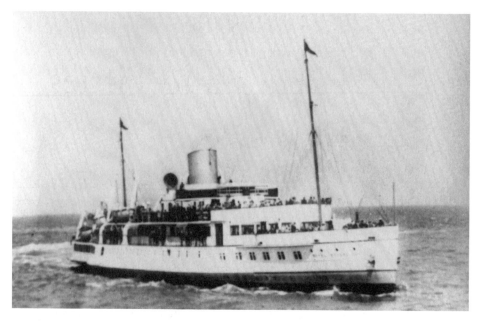

Royal Sovereign at sea around 1939. She had a trial speed of 21 knots and a gross tonnage of 1,527. A new feature was the upper decks that extended beyond the side of the hull on the sponsons.

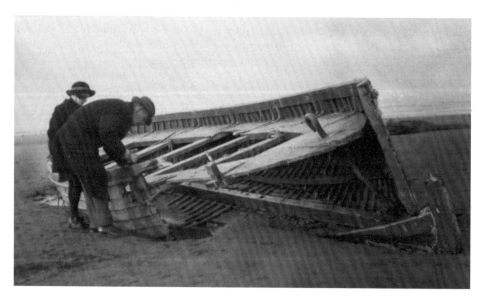

The first *Royal Sovereign* made four trips to the beaches of Dunkirk and two to La Panne and rescued some 12,000 men. Later in the year she struck a mine in the Bristol Channel on 9 December 1940 and was declared a total loss. Here, pleasure steamer historian Harold Collard Stone and his daughter Margaret are seen inspecting the wreckage of one of the wooden lifeboats from the *Royal Sovereign*. The photograph was taken on Berrow Sand. Harold collected wood from the wreckage and later made a model of the steamer. The model survives in the PSPS Collection.

Chapter 2

The Forties and Fifties

The Second World War took a terrible toll on the Thames and Medway excursion fleet as it did with civilian life. For many pleasure steamers, it was their finest hour as they were thrust onto an unlikely stage where they swapped their usual crowd of cheerful Londoners for war-ravaged troops during the miracle of Dunkirk. After six long years of conflict it would surely be back to life as normal … or would it? *Queen of the Channel*, *Royal Sovereign*, *Crested Eagle* and *City of Rochester* were all wartime losses and *Thames Queen* and *Laguna Belle* were classed as being unfit for further service and were therefore scrapped. But, famous old names such as *Golden Eagle*, *Royal Eagle*, *Royal Daffodil*, *Queen of Kent*, *Queen of Thanet* and *Medway Queen* all survived ready to recommence their happy peacetime role. The post-war fleet though had dwindled to some six vessels after a pre-war total of thirteen.

Royal Eagle and *Queen of Thanet* were first to re-enter service in 1946 and, in the following year, the popular *Royal Daffodil* undertook cruises to view the coastline of France once again. The remaining paddle steamers soon followed. A splendid new Denny-built *Queen of the Channel* entered Thames service in 1948 followed by an equally splendid *Royal Sovereign* in 1949. Surely, with this significant air of confidence, a new 'Golden Age' of Thames and Medway excursion pleasure steamers had dawned?

The mighty General Steam Navigation Company within a few short years looked towards shrinking its fleet. *Golden Eagle* was sold for scrap in 1951 and the almost new *Royal Eagle* followed the same fate in 1953. Thus, paddle steamer services on the Thames virtually ended. Only *Medway Queen* carried the mantle now.

By the mid-1950s, services more or less revolved around the three 'Eagle Steamer' motor ships. They were commonly known as the ocean liner for the masses and offered the very best in accommodation and facilities. They existed in a world that was rapidly changing from that of a generation earlier. Yes, there was still a traditional market of those that still yearned for a day at the coast with a stroll along the promenade. But for others, flexibility was the key and the motor car provided this and released people from the constraints of a rigid timetable or uncertain weather. Between 1950 and 1970 car ownership in London quadrupled. The younger generation were also looking for something more in tune with their needs bought on by a wider revolution in culture, music and dress. By the end of the 1950s, times were changing fast for the excursion fleet.

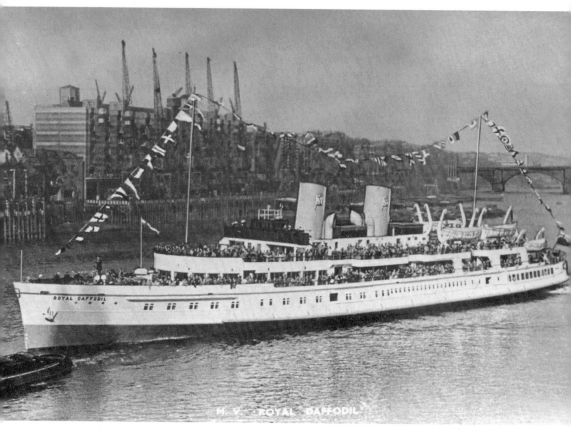

The Royal Daffodil was the only survivor from the pre-war motor vessel fleet. After her work assisting with the evacuation of children in 1939, she carried part of the British Expeditionary Force to France via Southampton and Cherbourg before her epic role at Dunkirk. *Royal Daffodil* completed seven trips to Dunkirk. On her final trip she was hit on the starboard side. The bomb passed through three decks and the engine room, causing it to flood. Everyone moved to the opposite side enabling the hull to be patched with mattresses and wood. With repairs complete, she limped back to Ramsgate. She was later taken to the GSNC yard at Deptford for full repairs. *Royal Daffodil* had suffered a great deal; one of the lifeboats had 187 holes in it. Between 1941-45 she was employed on the Larne-Stranraer military service before ending her wartime career employed on the Dover-Calais, Newhaven-Dieppe and B.A.O.R. service carrying troops home on leave.

Subject to alteration without notice.　　　1947 season.　　　Programme D.1.

COMMENCING 19th JULY

EAGLE AND QUEEN LINE STEAMERS

Purchase Tickets
in Advance

—

Travel Mid Week
for
Greater Comfort

Breakfasts,
Luncheons,
Teas and Snacks
served on Board

—

Fully Licensed

M/V ROYAL DAFFODIL

By Twin-Screw Motor Vessel ROYAL DAFFODIL
From GRAVESEND to
SOUTHEND, MARGATE
AND A
CRUISE ALONG THE FRENCH COAST
Between CALAIS and DUNKIRK

DAILY　　(Weather and other circumstances permitting)　　FRIDAYS EXCEPTED

LEAVE—		RETURN—	
GRAVESEND (West St.) S.R. Pier	8.50 a.m.	MARGATE	6.00 p.m.
SOUTHEND	9.50 a.m.	SOUTHEND	8.30 p.m.
MARGATE	12.15 p.m.	GRAVESEND	9.30 p.m.

FARES FROM GRAVESEND :
Children under three FREE.　　Three to fourteen years HALF-FARE

To	Single	Period Return	Day Return Sat., Sun. & Bank Hol.	Mid-Week Day Return Issued on Mon: Tues:, Wed: and Thurs only. Bank Holidays Excepted
SOUTHEND	3/6	6/-	6/-	5/-
MARGATE	8/-	12/6	12/6	10/6
COMPLETE DAY CRUISE TO FRENCH COAST - - - 20/-				

Passengers will not be permitted to travel on the outward journey on any date other than that stamped on the tickets. Period passengers should notify the date of return at time of booking. Supplementary charge for use of sun deck: 1/6 for the single journey, 2/6 return, payable on board only. Dogs not carried. No luggage allowed to day return passengers. Tickets in advance will be posted on receipt of remittance.
PASSENGERS ARE CARRIED ONLY ON THE TERMS AND CONDITIONS PRINTED ON THE COMPANY'S TICKETS.

The General Steam Navigation Company, Ltd.
15 TRINITY SQUARE, LONDON, E.C.3　　Telephone—Royal 4021

Sailings for the 1947 season by the *Royal Daffodil* from the West Street Pier at Gravesend. After the war, *Royal Daffodil* was de-requisitioned in January 1947 after carrying around 2.5 million servicemen and sailing almost 200,000 miles. She required work to re-equip her for her peacetime role but was hastily pressed into service. West Street Pier was situated below the railway track of Gravesend West station and still exists to this day although the railway station closed as a reaction to the Beeching cuts during the early 1960s. It was finally demolished during the 1980s.

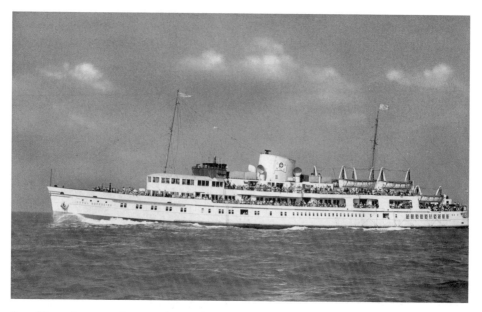

Royal Sovereign entered service during the 1949 season and replaced the wartime loss with the same name. She quickly became a firm favourite of the Thames excursion fleet. *Royal Sovereign* was initially placed on a direct service from Tower Pier to Margate. This fine view shows her considerable size and passenger-carrying abilities.

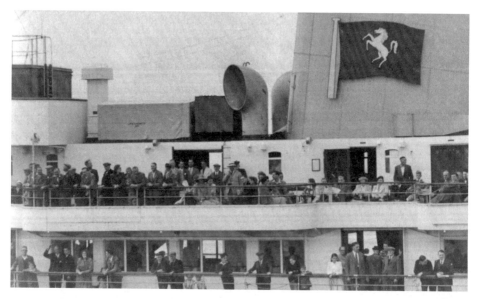

After the Second World War, the motor ships were given emblems on their funnels. *Royal Daffodil* and *Royal Sovereign* were given the GSNC flag and the *Queen of the Channel* was given the New Medway Company's emblem of the rearing horse 'Invicta' of Kent. After the withdrawal of the *Medway Queen* in 1963, *Queen of the Channel* was given the GSNC emblem as the New Medway Steam Packet Company had by then given up operating pleasure steamers.

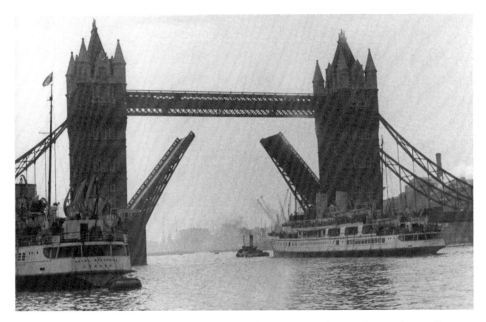

Royal Daffodil departing from London with *Royal Sovereign* tied up on buoys close to Tower Pier around 1950. *Royal Daffodil* had two sets of 12-cylinder Sulzer two-stroke marine diesel engines giving a speed of 21kt. She had a gross tonnage of 2,060 and a cruiser stern with two well-proportioned cream-painted funnels. Her hull was painted white with two green lines painted above the waterline and green boot topping below.

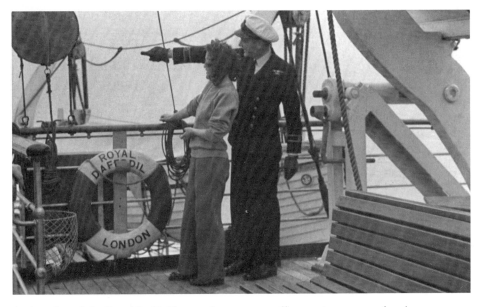

A view aboard the *Royal Daffodil* around 1947 as an officer assists a young female passenger. *Royal Daffodil* was a massive 299.7ft in length. She was almost twice the tonnage of the pre-war *Queen of the Channel*. Like the two other pre-war motor ships she was flared midships to allow extensive deck space and increased stability.

A charming study of passengers aboard the *Royal Daffodil* around 1955. Note the small bird that is the focal point of the photograph. The photograph was taken by an amateur photographer for inclusion in a competition run by the GSNC to find photographs for its souvenir guides each year.

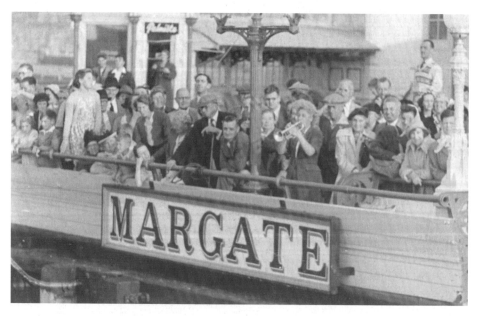

Crowds assembled on Margate Jetty, with a young woman playing a trumpet to serenade passengers aboard a pleasure steamer around 1950.

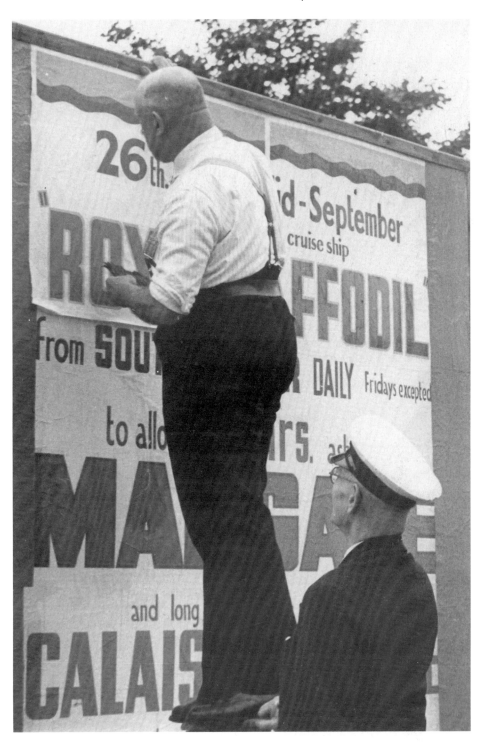

An evocative photograph showing a poster being hung by a billposter at Southend to advertise cruises by the *Royal Daffodil* to Margate and Calais around 1955.

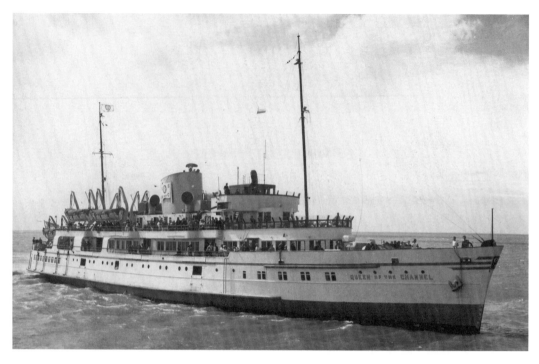

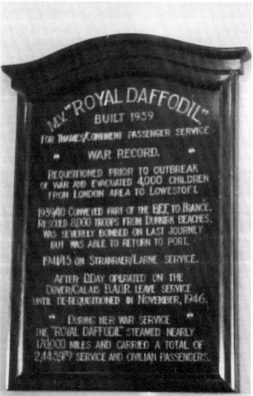

Queen of the Channel on one of her first cruises in 1948. At the time she had her off service day on Saturdays but worked on Fridays instead unlike other steamers at the time.

Plaque aboard the *Royal Daffodil* recording her proud record during the Second World War including evacuating schoolchildren when war was declared as well as later rescuing troops from the beaches of Dunkirk.

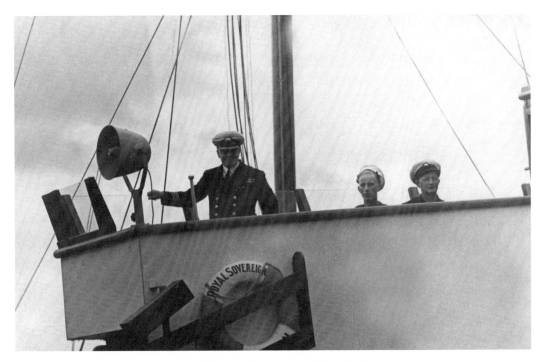

The Master on the Bridge wing of the *Royal Sovereign* during the late 1940s.

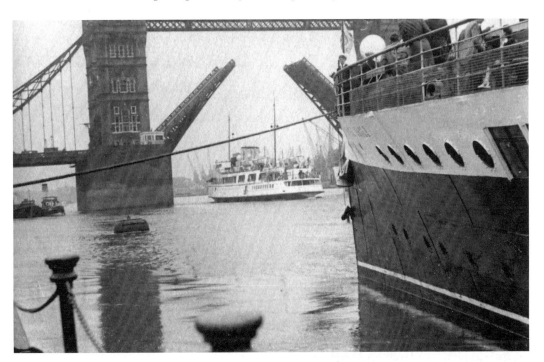

Royal Sovereign departing from London whilst the *Royal Eagle* lies alongside Tower Pier during 1949.

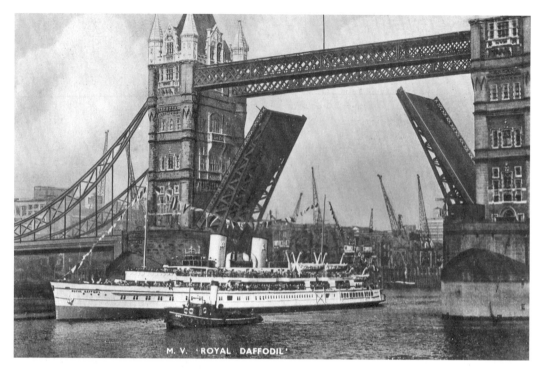

M. V. 'ROYAL DAFFODIL'

Royal Daffodil departing from London. She could accommodate 118 persons at one sitting in her dining saloon and had a self-service cafeteria where a further 168 could be seated. In addition there was a soda fountain as well as four bars.

A small detail of an Eagle Steamer rarely photographed.

Handbill advertising 'Queen Line' services by the *Medway Queen* from Herne Bay in 1956. Such cruises offering a combined cruise and train return and were a common feature of schedules, giving passengers the added bonus of a cruise in the River Medway in addition to the cruise between Herne Bay and Southend.

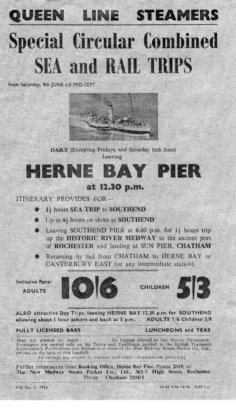

QUEEN LINE STEAMERS

Special Circular Combined SEA and RAIL TRIPS

from Saturday, 9th JUNE till MID-SEPT.

DAILY (Excepting Fridays, and Saturday 16th June)
Leaving

HERNE BAY PIER
at 12.30 p.m.

ITINERARY PROVIDES FOR—

● 1½ hours SEA TRIP to SOUTHEND
● Up to 4½ hours on shore at SOUTHEND
● Leaving SOUTHEND PIER at 6.40 p.m. for 1½ hours trip up the HISTORIC RIVER MEDWAY to the ancient port of ROCHESTER and landing at SUN PIER, CHATHAM
● Returning by rail from CHATHAM to HERNE BAY or CANTERBURY EAST (or any intermediate station).

Inclusive Fare:
ADULTS **10|6** CHILDREN **5|3**

ALSO attractive Day Trips, leaving HERNE BAY 12.30 p.m. for SOUTHEND allowing about 1 hour ashore and back at 5 p.m. ADULTS 7/6 Children 3/9

FULLY LICENSED BARS **LUNCHEONS and TEAS**

Dogs not allowed on board. No luggage allowed to Day Return Passengers.
Passengers are carried only on the Terms and Conditions printed in the British Transport Commission's Publications and Notices and those of the New Medway Steam Packet Co., Ltd., printed on the back of this handbill.
All sailings are subject to weather and other circumstances permitting.

Further information from Booking Office, Herne Bay Pier, Phone 2019, or The New Medway Steam Packet Co., Ltd., 365-7 High Street, Rochester. Phone : Chatham 2204/5

H.B. No. 2. 1956 W-45 5-56-14146 KAP Ltd

A perplexed officer aboard one of the motor ships during the mid-1950s. Deckchairs were always charged as an extra aboard the steamers.

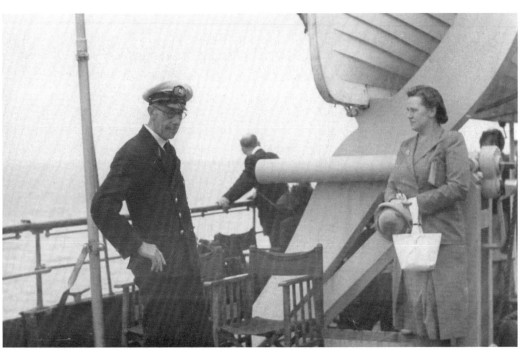

NO-PASSPORT
DAY EXCURSIONS
to
CALAIS BOULOGNE

by m.v. "**ROYAL DAFFODIL**" from **SOUTHEND PIER**

giving about **3 HRS. IN FRANCE**

SAILINGS FROM JUNE 27th UNTIL SEPTEMBER 16th
for British subjects — citizens of the United Kingdom and Colonies, the Irish Republic, Australia, Canada, Ceylon, India, Newfoundland, New Zealand, Pakistan, Southern Rhodesia and the Union of South Africa.

ON SATURDAYS SUNDAYS & THURSDAYS	ON WEDNESDAYS
BOULOGNE	**CALAIS**

TIMETABLE

SOUTHEND	...	dep.	10.00 a.m.	SOUTHEND	...	dep.	10.00 a.m.
BOULOGNE	...	arr.	2.00 p.m.*	CALAIS	...	arr.	2.00 p.m.*
„	...	dep.	5.00 p.m.	„	...	dep.	5.00 p.m.
SOUTHEND	...	arr.	9.00 p.m.*	SOUTHEND	...	arr.	9.00 p.m.*

*Times marked * are approximate*

N.B.—Passengers are required to be at Southend Pier not later than 9.30 a.m. for Immigration and Customs formalities.

FARES

DAY RETURN (No Passport)	WEEKEND RETURN (to Boulogne only—Passport essential)	PERIOD RETURN
37/6	60/-	70/-

Children: under 3 years, free; 3 to 14 years, half adult fares.

EXCELLENT CATERING (FULLY LICENSED) ABOARD

★ **REDUCED FARE FOR PARTIES BOOKED IN ADVANCE** ★

Attention is specially directed to Regulations overleaf

ADVANCE BOOKING RECOMMENDED

For full information, booking, and Embarkation Cards

EAGLE STEAMERS

PIER HILL, SOUTHEND-ON-SEA. 'Phone: 66597 (May/Sept.)

Jan. 1956.

By 1956, when this handbill was printed, no-passport cruises to Boulogne and Calais were incredibly popular. Passengers required three passport size photographs for their embarkation card which they had to present to immigration control prior to embarkation. The maximum amount of sterling notes permitted to be taken out of the UK was £10. A currency exchange office was provided aboard the *Royal Daffodil* to exchange money. Passengers could get exchange for up to £5 of French francs

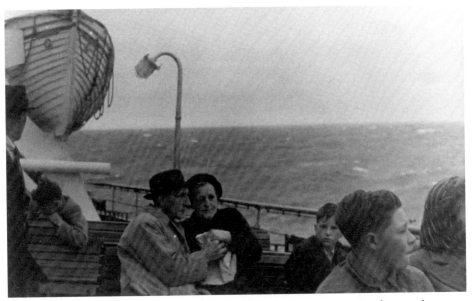

The GSNC motor vessels had ample deck space for their passengers to enjoy fine weather. But in rough seas, as can be seen in this photograph, this was no consolation! The poor lady is being comforted by her husband as she feels unwell and the cruise seems to be lasting an eternity for her!

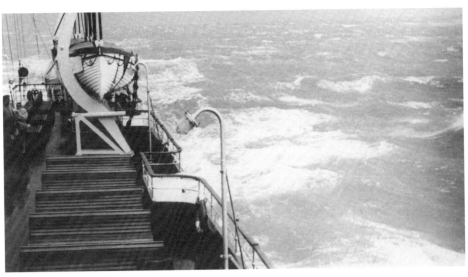

Does this bring back memories? When we think of the 'summer boats' we tend to think of idyllic summer days but just as memorable were the more challenging rough weather crossings of the English Channel. After a couple of hours of making a rough crossing, the poor passengers went ashore to recover whilst the exhausted crew with their strong stomachs had to clear up the mess. A distinctive smell of disinfectant met passengers as they embarked again for another dose of lively seas as they crossed the English Channel on the way home! Many passengers must have wished that they had gone to Margate instead as they would then be able to get a train home to London!

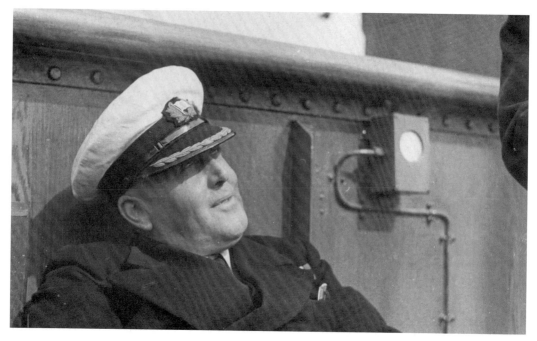

One of the GSNC captains relaxing on the Bridge aboard one of the motor ships in the years after the end of the Second World War.

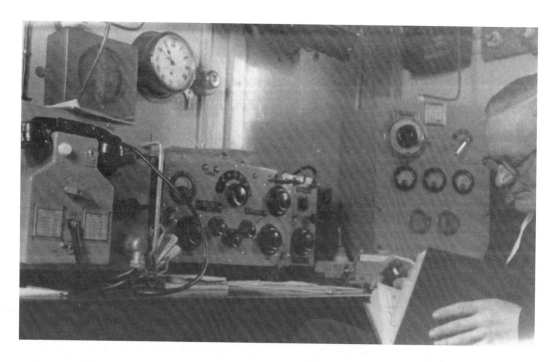

A photograph showing the radio room aboard one of the GSNC motor vessels in the late 1940s. The clock on the wall survives and is now in the PSPS Collection.

An unusual shot taken in one of the officers' cabins aboard one of the three motor vessels. Such areas were usually out of bounds to passengers and now give us a rare glimpse into the past.

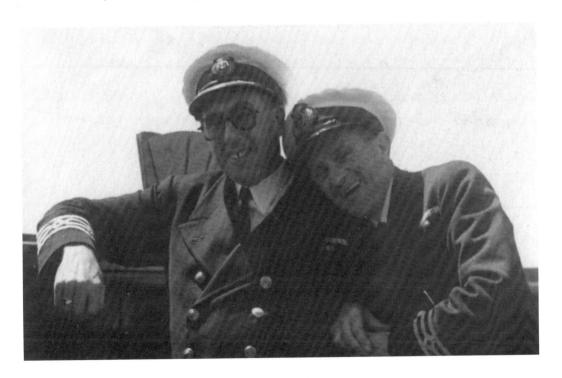

Happy days! Two officers enjoy a rare moment of relaxation.

EAGLE AND QUEEN LINE STEAMERS

From RAMSGATE (East Pier)

| The Luxury Liner T.S.M.V. QUEEN OF THE CHANNEL | Commencing **SUNDAY, 5th JUNE, 1949** (Weather and other circumstances permitting) | The Luxury Liner T.S.M.V. QUEEN OF THE CHANNEL |

EVERY SUNDAY at 12-30 p.m.

Special Channel Cruise Fare 10/6

OFF THE FRENCH COAST

EVERY TUESDAY, WEDNESDAY and THURSDAY at 10-20 a.m.

Seven Hours Channel Cruise

OFF THE FRENCH COAST

Calling DOVER And Returning from Dover at 4.30 p.m.

FARES:

Channel Cruise 12/6. Dover (Single) 4/-. Dover (Return) 5/6

Combined Boat/Bus Ticket (Passengers return by any Dover/Ramsgate East Kent Bus) 6/-

At 6.15 p.m.

Two and a Half Hours Cruise

TO TONGUE FORT (Calling Margate) 4/6

EVERY FRIDAY at 10-20 a.m.

Special Channel Cruise

via Margate, returning Ramsgate 4.30 p.m. 12/6

Commencing SATURDAY, 18th JUNE, 1949 until further notice

P.S. ROYAL EAGLE

Will leave Ramsgate at 2-30 p.m. DAILY, Except Friday for

MARGATE, SOUTHEND, GREENWICH & LONDON

FOR FARES SEE HANDBILLS OR ENQUIRE BELOW

Why not take a combined Steamer/Bus Ticket to Margate and return by any East Kent Bus the same day, Fare 3/-

PLEASE BOOK EARLY AT PIER YARD OFFICE, OPEN FROM 9 a.m.

No Dogs allowed on the Company's Vessels. Children under 14 Half Fare, under 3 years Free Passengers are only carried on the terms and conditions printed on the Company's Tickets

EAGLE & QUEEN LINE STEAMERS, RAMSGATE, Tel. Ramsgate 1179

Hanging card advertising cruises by the almost new *Queen of the Channel* during the 1949 season from Ramsgate. Services by the soon to be withdrawn *Royal Eagle* are also listed. The reverse of the card includes details of round trips to Dover aboard the *Queen of the Channel*. During the 1940s passengers were given the opportunity to go by pleasure steamer to Dover and then spend time ashore before returning home to Ramsgate by any bus of the East Kent Road Car Company Limited.

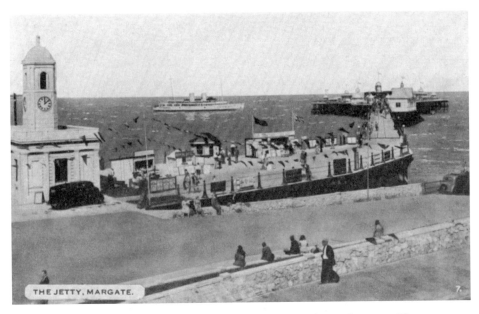

Margate Jetty with the *Royal Daffodil* approaching sometime during the 1950s. The area adjacent to the jetty will soon become the Turner Contemporary Arts Centre. J.M.W Turner lodged at a house roughly at the right of this view when he painted at Margate. He said that 'the skies over Thanet are the loveliest in all Europe'.

Above left: A view of an office aboard one of the motor pleasure steamers. Copies of the timetable booklets can be seen pinned to the wall.

✶ **NO PASSPORT**

DAY EXCURSIONS to

BOULOGNE

(for British subjects only)

by m.v. "ROYAL DAFFODIL"

FROM SOUTHEND PIER

EVERY WEDNESDAY, SATURDAY & SUNDAY & ON AUGUST BANK HOLIDAY

at **10** a.m. | Day **35/-** Ret. | **CHILDREN** up to 14 yrs. **17/6**

giving about **3 HRS. IN FRANCE**

29TH JUNE TILL 11TH SEPTEMBER, 1955

Outwards	TIMES	Homewards
Southend, *dep.* **10 a.m.**		**Boulogne,** *dep.* **5 p.m.**
Boulogne, *arr.* **2 p.m.**		**Southend,** *arr.* **9 p.m.**

N.B. PASSENGERS ARE REQUIRED TO BE AT SOUTHEND PIER NOT LATER THAN 9.30 a.m., FOR IMMIGRATION AND CUSTOMS FORMALITIES

ATTENTION IS SPECIALLY DIRECTED TO REGULATIONS OVERLEAF

1. Week-end and period bookings also carried by Saturday sailings, and period bookings also on Sundays. Passports necessary.
2. Good reductions for Parties. Fully licensed Catering.

ADVANCE BOOKING RECOMMENDED

FOR INFORMATION, BOOKING AND EMBARKATION CARDS

EAGLE & QUEEN LINE STEAMERS

PIER HILL, SOUTHEND

Telephone: 66597 (May/Sept.)

Handbill for sailings by the *Royal Daffodil* from Southend to Boulogne during the 1955 season when pleasure steamers were able to land passengers again rather than offering them a French coast cruise. Passengers couldn't take more than £10 sterling or more than £25 in foreign currency out of the UK during these cruises.

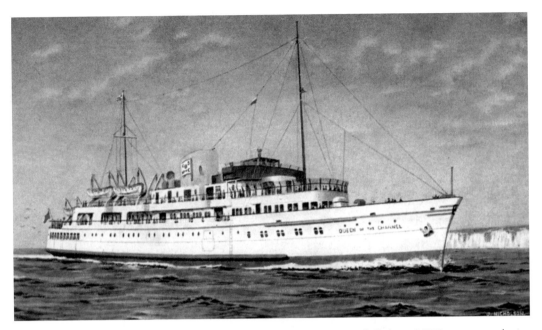

A well-loved postcard of the *Queen of the Channel* from a series of all three GSNC motor vessels painted by well-known maritime artist John Nicholson.

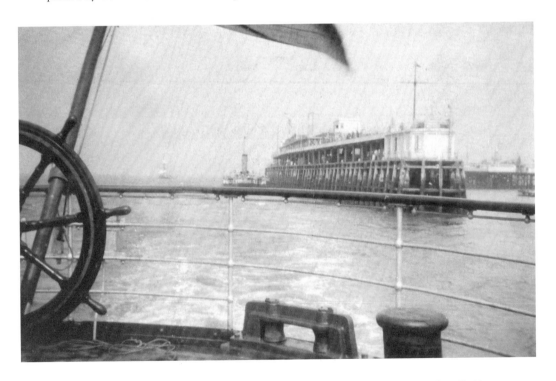

Southend Pier with *Medway Queen* alongside viewed from the stern of the *Royal Daffodil* on 14 July 1949.

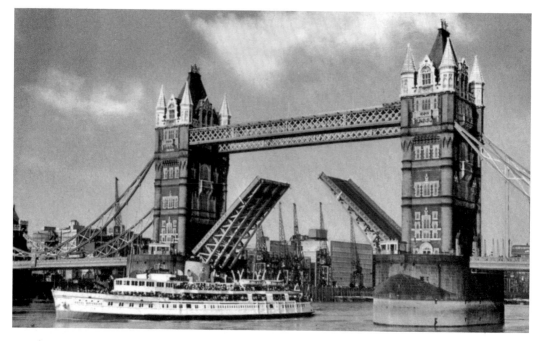

Royal Sovereign passing under the raised bascules of Tower Bridge during the late 1950s. The area at the stern of the *Royal Sovereign* is now the crash helmet-shaped home of the Mayor of London and the Greater London Assembly.

General Steam Navigation Company crew members operating a motor launch around 1955.

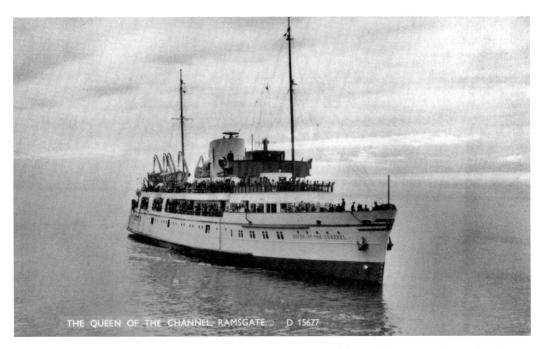

THE QUEEN OF THE CHANNEL, RAMSGATE. D 15677

Queen of the Channel approaching Ramsgate. During the early part of her career she was based at Ramsgate and ran cruises to Dover and to off Dungeness as well as to view the French coast.

The interior of one of the deck saloons aboard a Thames motor vessel during the 1950s.

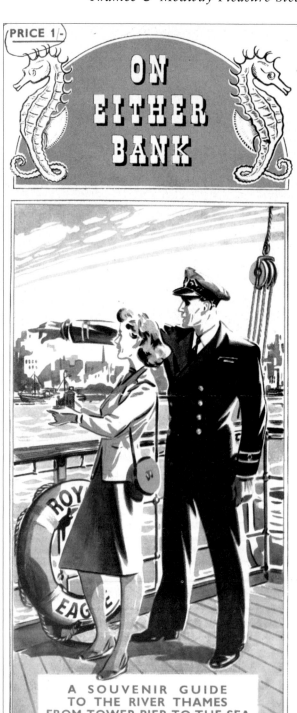

PRICE 1/-

ON EITHER BANK

A SOUVENIR GUIDE
TO THE RIVER THAMES
FROM TOWER PIER TO THE SEA

PUBLISHED BY THE GENERAL STEAM NAVIGATION CO. LTD.
15, TRINITY SQUARE, LONDON, E.C.3, ENG.

Most passengers aboard the pleasure steamers purchased a guide of some sort. This one 'On Either Bank' folds out to reveal a map along with places of interest during the cruise. Others were more elaborate and included detailed histories of the General Steam Navigation Company, details of cruises and articles on seaside resorts visited by the steamers.

Group charters were always important business for the GSNC. In an era when company or social group outings were commonplace, good discounts were given for groups and the three motor vessels were able to offer ample and varied accommodation for groups to popular seaside destinations. This image shows the *Royal Daffodil* alongside Southend Pier during the late 1950s.

Captain Philip Kitto aboard the *Queen of the Channel* at Clacton. He spent his early career with the 'Queen Line' pleasure steamers during the 1930s and was later master on the motor ships. Captain Kitto died after a heart attack during the 1950s. His war medals are now on display at Chatham Historic Dockyard.

EAGLE AND QUEEN LINE STEAMERS

The New Super Liner—T.S.M.V.

'QUEEN OF THE CHANNEL'

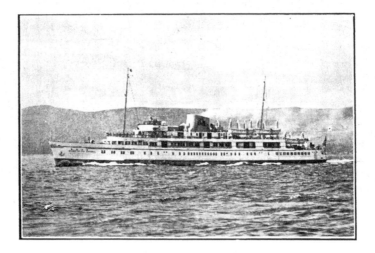

WILL SAIL FROM
THE EAST PIER, RAMSGATE HARBOUR
(Weather and other circumstances permitting)
EVERY SUNDAY AT 12.30 p.m.
(Until Further Notice) for an

Interesting & Enjoyable Cruise
OFF THE FRENCH COAST
Returning approximately at 4.50 p.m.
Fares : Adults 10/6 ; Children ($^{3 \text{ to } 14}_{\text{years}}$) 5/3

**This Magnificent New Vessel, launched this year,
accommodates about 1,500 Passengers.
The First Class Catering Service is a Special Feature.
Restaurants, Cafeteria and Fully Licensed Bars on Board.**

Passengers are only carried on the terms & conditions printed on the Company's tickets
No dogs allowed on board the Company's Vessels
EAGLE AND QUEEN LINE STEAMERS, RAMSGATE Tel. 1179

Printers—Bligh & Co., Ltd.. Ramsgate

Handbill from 1949 advertising cruises by the new 'super liner' *Queen of the Channel* from the East Pier at Ramsgate. For many years the Eagle Café adjacent to the steamer berth attended to the needs of passengers disembarking or embarking on the pleasure steamers.

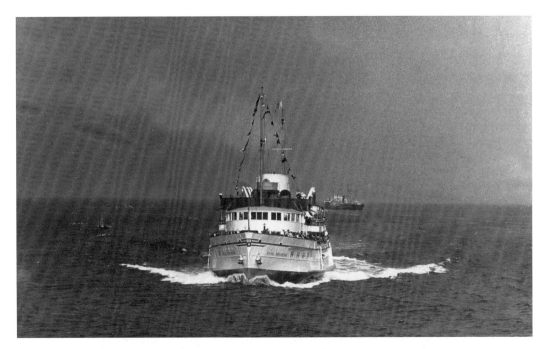

The *Royal Sovereign* about to arrive at Southend Pier during the 1950s. The photograph shows the great width of these motor ships.

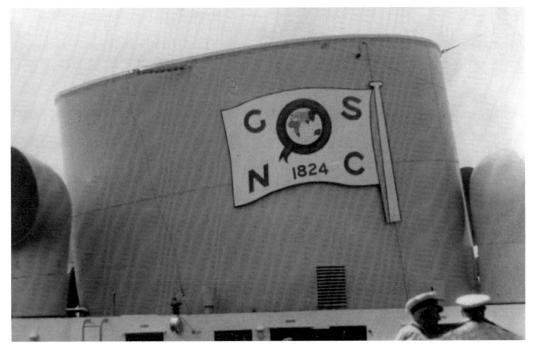

The funnel of the *Royal Sovereign* and the familiar badge of the General Steam Navigation Company. The GSNC flag was white with a red emblem.

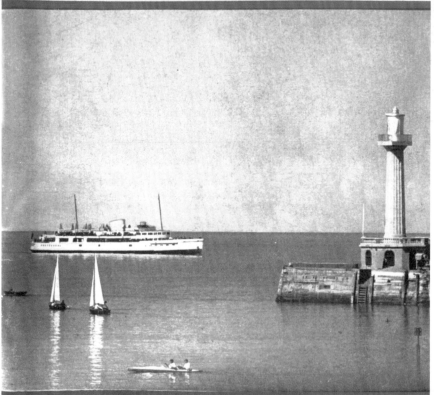

Cover from 'Seawards' the Eagle & Queen Line souvenir guide for 1950. These books were popular souvenirs aboard the pleasure steamers and were sold for 1s 6d and included full details of places of interest during the cruise along with ideas of what to do when you reached your final destination.

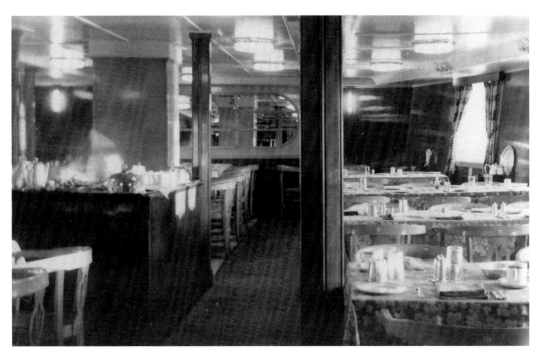

The Forward Dining Saloon of the *Queen of the Channel* in 1952. The styling of this saloon, with its curved mirror, fabrics, furniture and lighting, is very atmospheric of the Thames motor vessels.

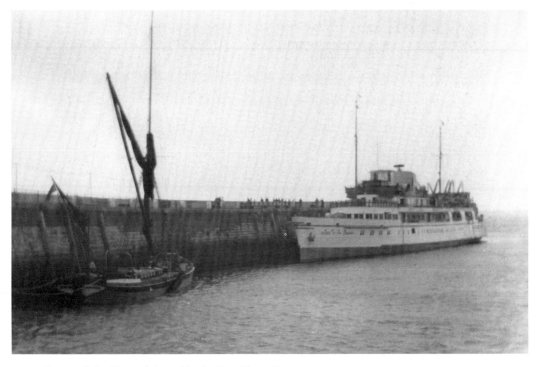

Queen of the Channel alongside the East Pier at Ramsgate.

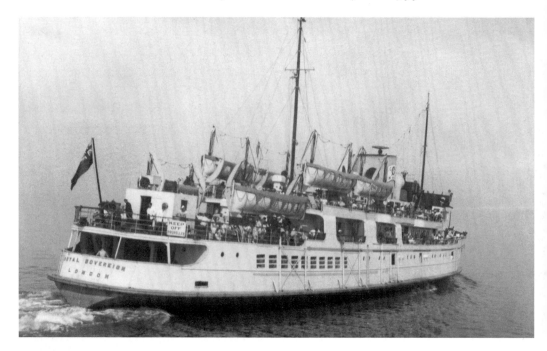

A stern view of the *Royal Sovereign* departing from Margate on 25 August 1952.

Captain Paterson joined the GSN summer service in 1938 and took over the command of the *Queen of Southend* along with Captain Johnson when she was renamed *Thames Queen*. The partnership greatly impressed GSN who gave the men command of the flagship *Royal Daffodil* for the 1939 season. On the outbreak of war, both men remained with the vessel and were later awarded the Distinguished Service Cross in recognition of their wartime role. Captain Paterson was a regular post-war master of the *Royal Daffodil*.

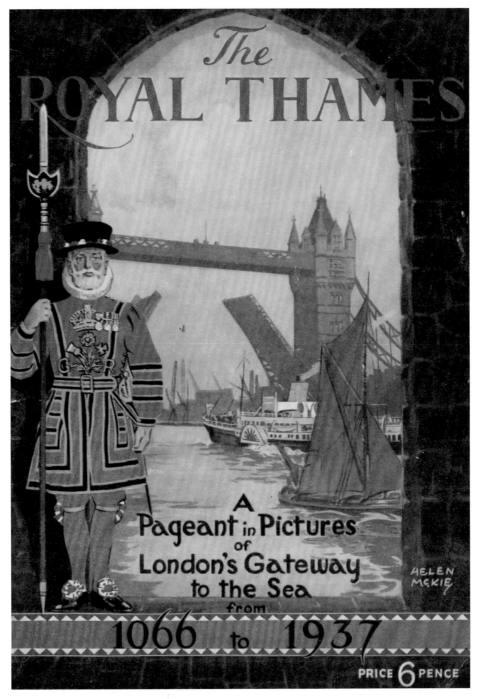

The ROYAL THAMES

A Pageant in Pictures of London's Gateway to the Sea from 1066 to 1937

HELEN McKIE

PRICE 6 PENCE

1. 'Eagle and Queen Line' souvenir brochure for 1937. In May, the Coronation of George VI took place at Westminster Abbey. The company produced lavish brochures that included a guide to the pleasure steamer routes, places visited and advertisements for the resorts. The evocative illustrations were painted by Helen McKie, a well-known artist who also produced work for the Southern Railway and the Ritz Hotel.

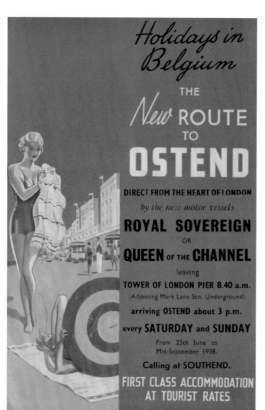

2. Brochure from 1938 advertising holidays in Belgium by the new motor vessels *Royal Sovereign* and *Queen of the Channel*. Weekend fares from London to Ostend were offered at 22s 6d for adults. It was primarily a direct service for continental traffic although a stop was made at Southend to embark further passengers.

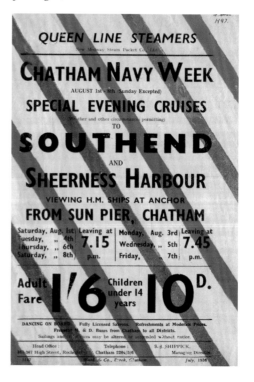

3. Handbill advertising special evening cruises from Sun Pier at Chatham during 'Navy Week' at Chatham Dockyard in August 1936. Navy Days were extremely popular events for the public and many cruises were offered to ensure maximum profit from the annual event. Another regular attraction was the various Thames sailing barge matches and the pleasure steamers were used to view these or to act as the official vessel for the committee.

4. 'Now and Then' – the holiday guide produced by 'Eagle and Queen Line Steamers' in 1939. It shows a view of the new *Royal Daffodil* on the front cover as well as a paddle steamer from 1824. Inside, it includes images from the Victorian era set against ultra modern views of the *Royal Daffodil*.

5. 1935 saw the Silver Jubilee of George V. 'Queen Line Pleasure Steamers' offered special cruises from London, Greenwich, North Woolwich and Gravesend to view the Royal Navy fleet anchored off of Southend as well as offering a special hour-long visit to look over HMS *Hood*. Seaside resorts such as Southend offered special events to commemorate the Silver Jubilee. The handbill also notes the first cruises of the new *Queen of the Channel* from 1 July 1935.

6. Brochure advertising cruises to Kent and Essex resorts as well as to the continent during the 1938 season by 'Eagle & Queen Line Steamers'. The modern style of the brochure reflects the modernity of the new steamers *Queen of the Channel* and *Royal Sovereign* both of which were built for continental service. These brochures included comprehensive details of the resorts visited, facilities onboard and places to see along the route. Special short breaks were also offered to First World War battlefields such as Ypres and Vimy Ridge.

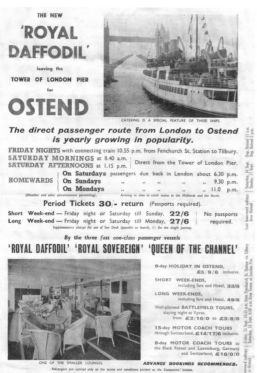

7. Handbill advertising cruises by the new *Royal Daffodil* from London to Ostend. She was ideal for the growing service to Ostend.

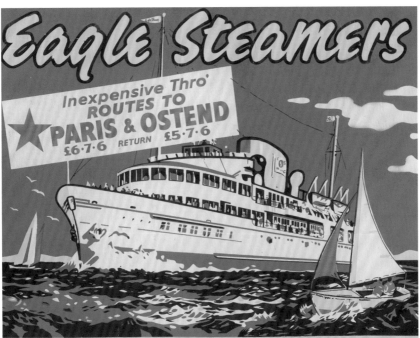

8. Poster advertising 'Eagle Steamer' services from London around the early 1960s when 'Rock Across the Channel' cruises usually left Gravesend for Calais with a varied bill of musicians who played throughout the cruise. They were a tremendous success with names such as Gene Vincent, Jerry Lee Lewis (backed by Chas Hodges of 'Chas & Dave' fame), Don Arden (father of Sharon Osbourne), Ray Charles and James Brown entertaining the teenage passengers.

9. *Queen of the Channel* at Calais. The 'no passport' cruises did good business throughout the late 1950s and early 1960s. In 1957 there were 61,300 passengers; 78,500 in 1958; 77,164 in 1959 and 78,031 in 1960.

10. *Queen of the Channel* departing from Calais around 1962. Services by the three motor ships witnessed a declining market. Throughout 1963, 1964 and 1965 they continued on their usual routes. By 1965 GSN were offering a novel service to Barcelona whereby the *Royal Daffodil* offered the steamer service to Calais. Passengers then travelled by train and coach to Barcelona. The journey took some 35 hours and cost £20.75.

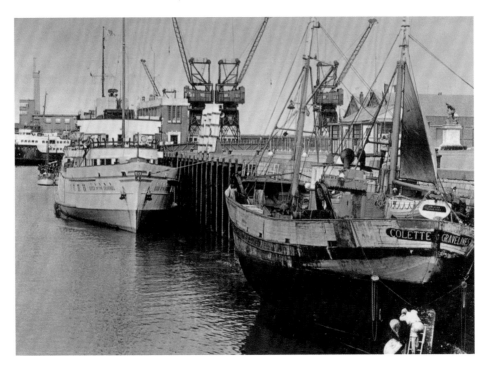

11. *Queen of the Channel* at Calais around 1963. Calais remained a popular destination for excursion passengers and gave a glamorous 'continental' feel to the day at sea.

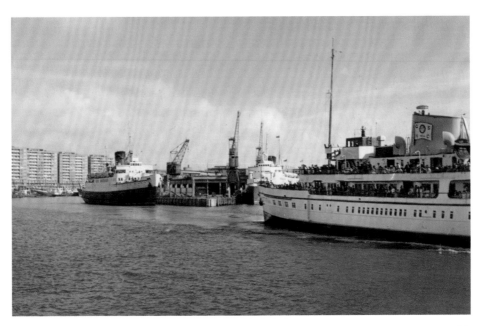

12. *Queen of the Channel* entering the port of Boulogne around 1960. GSNC did all that they could to increase revenue and many innovations were added. Towards the end in 1966, all three steamers were fitted with 'one arm bandits' on 'C' deck. These were patronised very well but unfortunately takings in the bars on this deck were down. It seemed that GSNC's gamble didn't win!

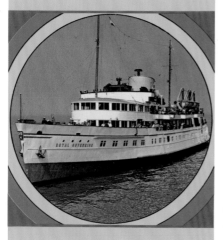

13. *Left:* An unusual souvenir – a cocktail coaster showing the *Royal Sovereign* printed as a postcard to send to friends. With a swift cut with a pair of scissors your postcard was transformed into a handsome and useful object!

14. *Below: Royal Daffodil* approaching Southend Pier on a charter during the early 1960s. By 1962, the decline in passenger numbers was obvious. The *Royal Sovereign* carried 127,644 (143,969 in 1961), *Royal Daffodil* 29,772 (32,907) on 'No-Passport' cruises and 26,907 (45,363) on other sailings, *Queen of the Channel* 47, 407 (50,059) and *Medway Queen* approximately 48,000 (52,449).

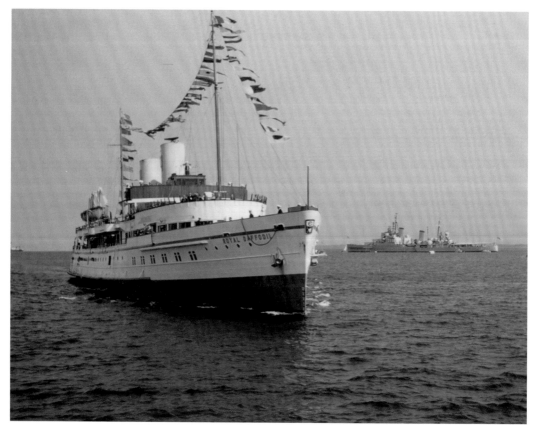

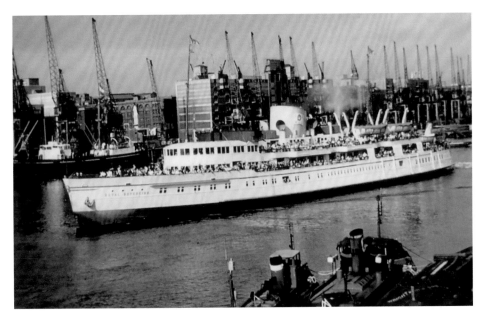

15. *Royal Sovereign* embarking on a cruise from London in 1965. The size of these steamers was immense and was further exaggerated by the white, cream and green livery. Up to twice the size of *Waverley*, their size made them tremendous for making money in good times but in bad times losses could be quite substantial.

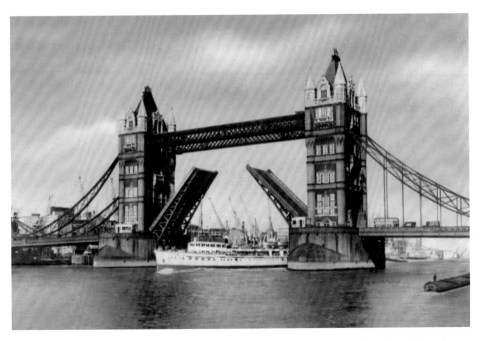

16. *Royal Sovereign* at Tower Bridge. By the mid-1960s, it was apparent that the end was in sight for Thames steamer services as a radical restructure was taking place of services. *Royal Sovereign* for the first time ever was based at Great Yarmouth for long trips to Calais as well as for shorter local trips. Cruises from Clacton to Calais were offered midweek.

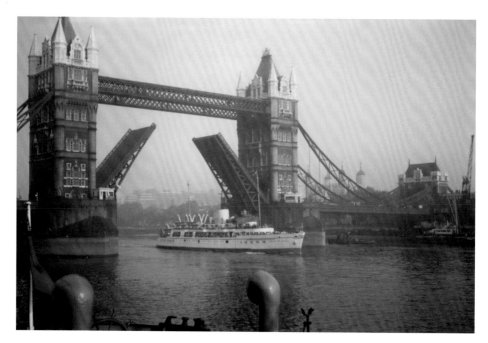

17. *Queen of the Channel* departing from London in June 1955 viewed from the *Medway Queen*. At the time, *Medway Queen* had been chartered by London grocer Don Rose to thank his customers for their loyalty during the Second World War. It was thought at the time that this rare visit by the *Medway Queen* would be the last ever visit by a paddle steamer to London.

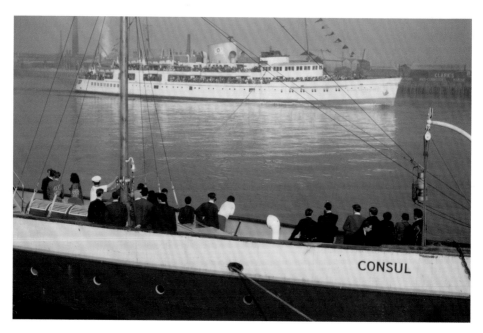

18. The well-loved sixty-seven-year-old *Consul* alongside Greenwich Pier in September 1963 with the sprightly and modern fifteen year old *Royal Sovereign* passing with a full load of passengers. *Consul* had originally been built as *Duke of Devonshire* on the London River in 1896.

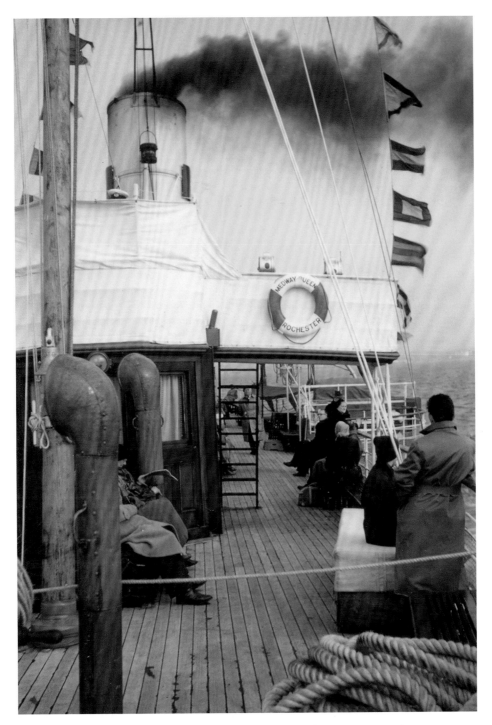

19. *Medway Queen* during the late 1950s. She was the first Thames steamer to have a Promenade Deck running from the bow to the stern and had a Bridge in front of the funnel and had full width saloons. She resembled the *Bournemouth Queen*, which was also built by Ailsa Shipbuilding of Troon.

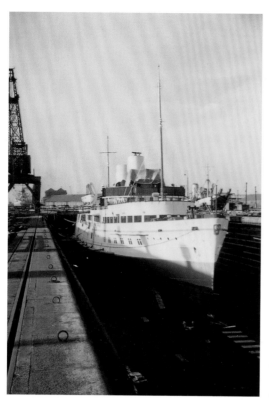

20. *Left:* A rare photograph showing *Royal Daffodil* in dry dock around 1965. At 313ft in length with a breadth of 50ft and a 9ft draught, *Royal Daffodil* was huge. Her bunkers could hold 70 tons of fuel oil. She could carry a staggering 2,073 passengers at a time during the summer months. During the winter of 1962/63 *Queen of the Channel* wintered in a creek close to Rochester railway station, *Royal Daffodil* was in the West India Dock and *Royal Sovereign* was at Stowage Wharf on the Thames.

21. *Below: Consul* at Greenwich in 1963. The short season by *Consul* wasn't a great success with only around 100 passengers being carried on each trip. She also arrived back home between one and two and a half hours late after each day of cruises which didn't help matters. At the end of her brief season she lay on buoys at Deptford until 7 October when she sailed for Weymouth.

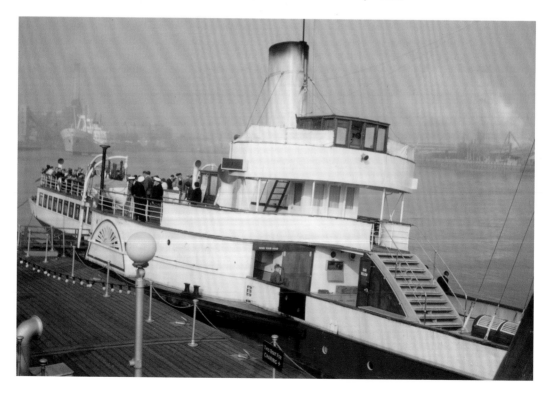

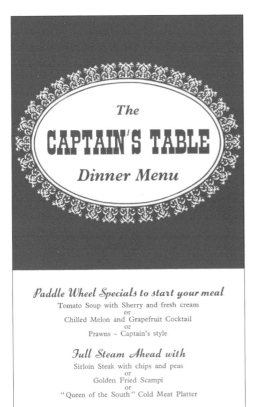

The
CAPTAIN'S TABLE
Dinner Menu

Paddle Wheel Specials to start your meal
Tomato Soup with Sherry and fresh cream
or
Chilled Melon and Grapefruit Cocktail
or
Prawns - Captain's style

Full Steam Ahead with
Sirloin Steak with chips and peas
or
Golden Fried Scampi
or
"Queen of the South" Cold Meat Platter

Anchors Down with
Sailors Cassata
or
Fresh Pineapple and cream
(*when available*)
or
Fruit from the basket
or
Cheese from the tray
(*as an extra course 2/6*)

and to finish your meal
Coffee served black or with fresh cream (1/6 extra)

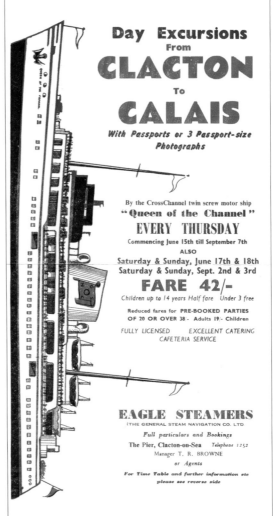

Day Excursions
From
CLACTON
To
CALAIS
With Passports or 3 Passport-size Photographs

By the CrossChannel twin screw motor ship
"Queen of the Channel"
EVERY THURSDAY
Commencing June 15th till September 7th
ALSO
Saturday & Sunday, June 17th & 18th
Saturday & Sunday, Sept. 2nd & 3rd
FARE 42/-
Children up to 14 years Half fare Under 3 free
Reduced fares for PRE-BOOKED PARTIES OF 20 OR OVER 38 - Adults 19/- Children
FULLY LICENSED EXCELLENT CATERING
CAFETERIA SERVICE

EAGLE STEAMERS
(THE GENERAL STEAM NAVIGATION CO. LTD)
Full particulars and Bookings
The Pier, Clacton-on-Sea *Telephone 1252*
Manager T. R. BROWNE
or Agents
*For Time Table and further information etc
please see reverse side*

22. *Above left:* 'Captain's Table' dinner menu from the *Queen of the South* in 1967. There was a real effort to make the ship offer something a little different from its competitors. The product and concept was very good but unfortunately was let down by mechanical and staffing problems. Don Rose was said to be left 'ill and heartbroken' by the failure of the venture.

23. *Above right:* Handbill advertising day excursions from Clacton to Calais by the *Queen of the Channel* during the 1960s. The cruise in each direction was seven and a half hours with three hours ashore.

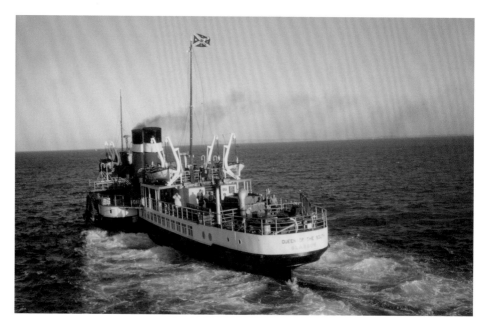

24. *Queen of the South* departing from Southend. Those behind the *Queen of the South* venture really attempted to provide every possible amenity for passengers. Her facilities included a well-appointed restaurant, a soda fountain offering ice creams, soft drinks and confectionery and a seafood bar where Leigh cockles and Margate shrimps were served. In addition, a 'Melotone' (an early form of electronic organ) provided music, giving a genuine showboat feel for passengers.

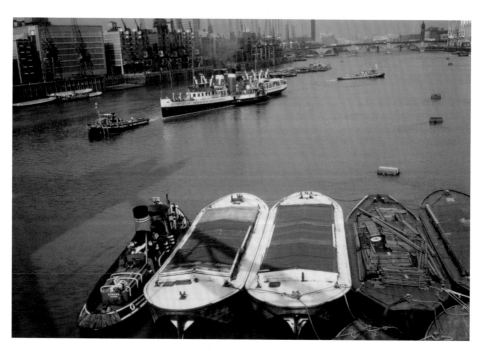

25. *Queen of the South* being towed towards Tower Bridge on 10 June 1967.

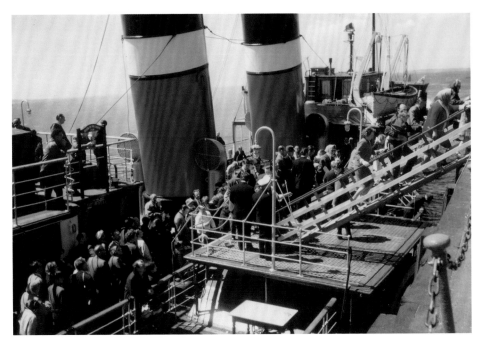

26. *Queen of the South* viewed from Southend Pier. The well-loved former LNER paddle steamer *Jeanie Deans* was purchased for further service on the Thames in 1965. After a generous amount of money was spent on her refurbishment, she entered Thames service in the following year.

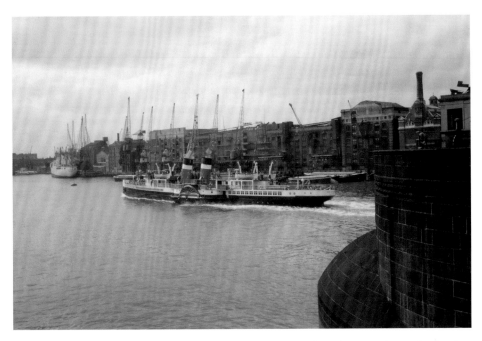

27. *Queen of the South* was intended to operate daily (except Fridays) from London to Southend and Herne Bay or Clacton. This valiant attempt led by Don Rose soon failed. Just eleven years later, *Queen of the South*'s former Clyde fleetmate *Waverley* became a great success story on the Thames.

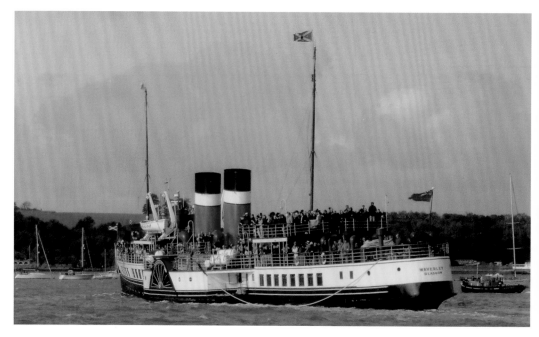

28. *Waverley* with crowded decks during the 'Grand Parade of Steam' on the River Medway off of St Mary's Island in 2003. Both *Waverley* and *Kingswear Castle* have met together on the river to greet each other since the restoration of *Kingswear Castle* in the mid-1980s.

29. A splendid-looking *Kingswear Castle* alongside Tower Pier London around 1985. As well as an annual visit to the 'Gravesham Edwardian Fair', *Kingswear Castle* also made an annual visit to London in her early years to undertake lucrative charters in the capital as well as carrying passengers to and from London.

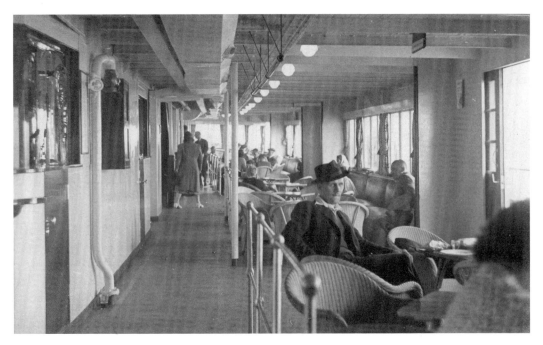

A spacious and well-appointed deck lounge aboard one of the GSNC motor vessels with doorways opening out onto the deck and seating either side of a central block of facilities and offices.

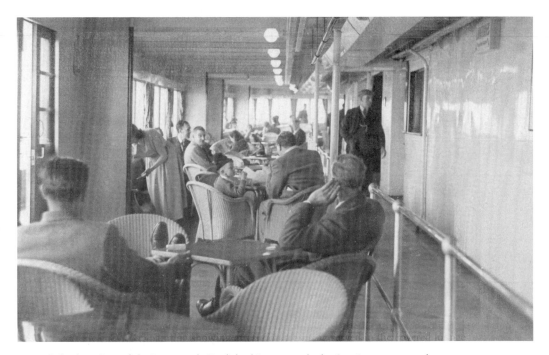

A further view of the Promenade Deck looking towards the Sun Lounge around 1955.

Subject to alteration without notice 1953

EAGLE STEAMERS

CORONATION CRUISES TO THE SEA
by M/V Royal Daffodil

Daily (Fridays excepted)
Weather and other circumstances permitting
from
GRAVESEND (Stuart Road Pier)
at 9 a.m. sharp, for a
CRUISE TO THE FRENCH COAST
Calling at SOUTHEND and MARGATE
Passengers for Clacton change at Southend

For full information, tickets in advance and on day of sailing apply—
T. J. LOFT & SONS, 39 New Road and 4 Town Pier, Gravesend
Telephone—1156 & 1000
Office hours: 7.30 a.m—6 p.m. Wednesdays included. Sundays 7.30—8.45 a.m.

Handbill advertising cruises by the *Royal Daffodil* during the year of Queen Elizabeth II's coronation in 1953 from Gravesend's Stuart Road Pier. Cruises were offered to Southend and Margate and to off the French coast for 21s. In the days before mobile communications, it was possible to make telephone calls from the *Royal Daffodil* at a cost of half the fare (10s 6d) for three minutes or telegrams could be sent for 6d per word.

Passengers crowd the decks during a club charter around 1949.

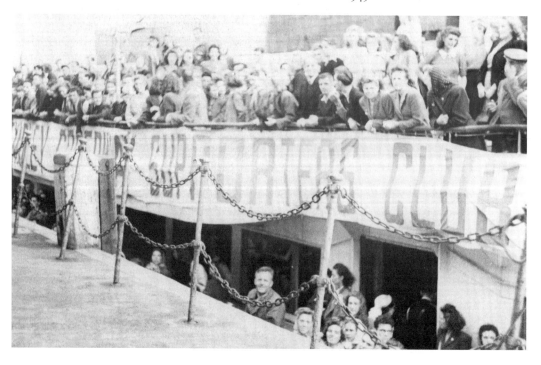

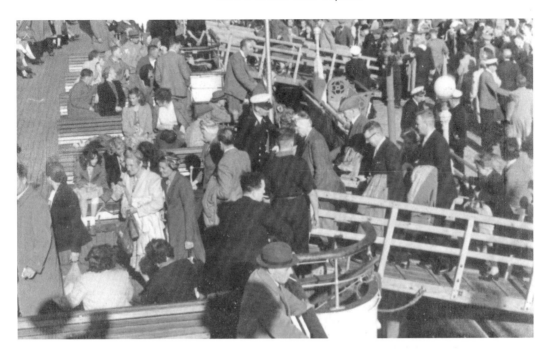

Passengers boarding a motor ship
around 1950 at Margate. At times
the busy Purser may have had to deal
with over 2,000 people embarking
and disembarking at a busy pier
such as Southend. He possessed a
huge variety of brightly coloured and
patterned card tickets to show what
destination you were travelling to
or from as well as an equally large
number of tickets for meals.

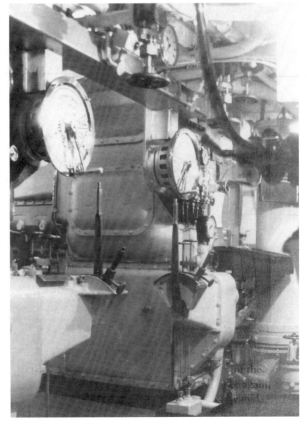

Engine controls of the *Queen of the
Channel* in June 1958.

Royal Daffodil alongside Boulogne around 1958. The cross-Channel ferry *Canterbury* is just departing on her way back to Dover.

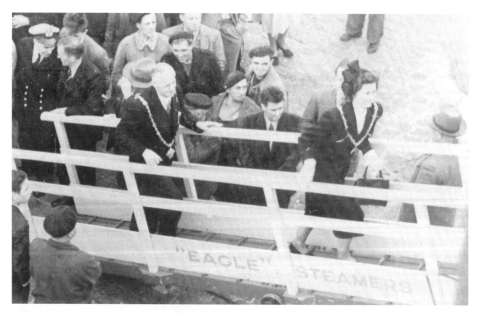

3.00pm exactly on 31 May 1950 when the *Royal Daffodil* made a special commemorative cruise from Margate on the tenth anniversary of Dunkirk. Here the Mayor of Margate (Councillor C.B. Hoskin) and the Mayoress rejoin the *Royal Daffodil* at Dunkirk after the special service ashore. Many former GSNC masters were aboard including ex-Commodore Bill Branthwaite, the popular master of the *Royal Eagle* before the war who had retired at the end of the Second World War.

French port officials at the gangway of the *Royal Daffodil* in 1950 as passengers embarked on the cruise back to the UK after their time ashore at Dunkirk for the commemorations.

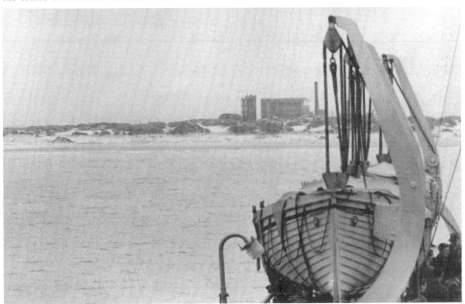

The war-ravaged beaches of Dunkirk viewed from the *Royal Daffodil* on 31 May 1950. At Dunkirk, the Mayor of Margate and his party went ashore and were received by the Mayor of Dunkirk. A casket made of oak from the Holy Trinity Church Margate (destroyed by enemy action in 1943) and containing Margate sand was presented to the Mayor of Dunkirk. A similar casket with sand from Dunkirk was presented once the *Royal Daffodil* returned to Margate.

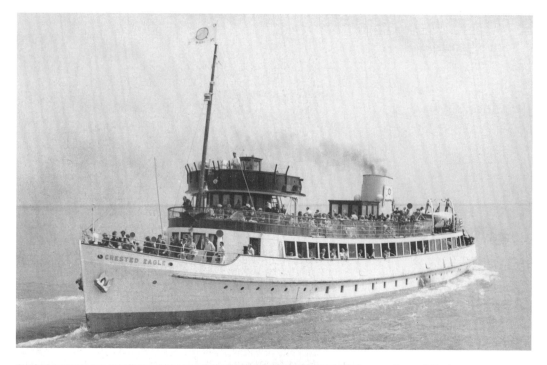

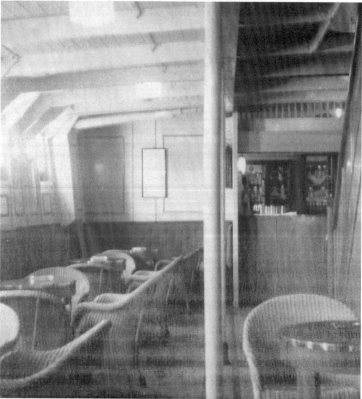

Crested Eagle was originally built as *New Royal Lady* for service out of Scarborough in 1938. In November 1947 she was purchased by GSNC for service on the Thames on dock cruises as well as from Tower Pier to Gravesend and Southend.

Lounge and bar on the lower deck of the *Crested Eagle* around 1956. *Crested Eagle* was a great deal smaller than the three GSNC motor ships, as can be seen by the more intimate saloon shown in this image.

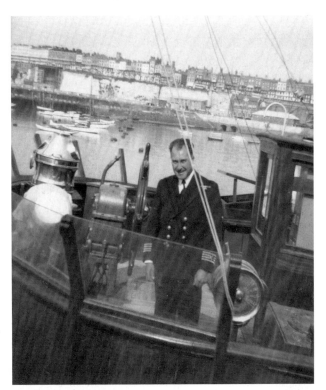

The master on the Bridge of the *Crested Eagle* at Ramsgate in 1952. *Crested Eagle* was later chartered to P&A Campbell for service out of Eastbourne and Hastings towards the end of the 1950s before further service out of Malta.

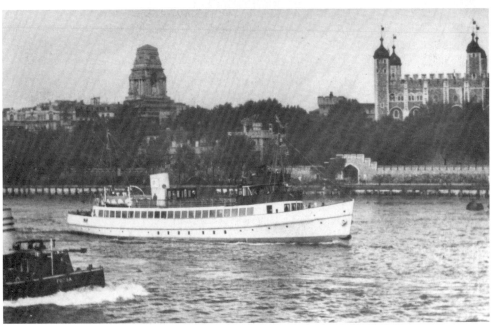

From 1952, *Crested Eagle* was based at Ramsgate before later moving to Gravesend for Southend and Clacton. *Crested Eagle* was 138ft in length and had a speed of 13kt. She could carry up to 670 passengers.

Captain Paterson had a reputation for being a very sociable person. He would often invite several friends onto the Bridge or to his cabin during a Channel cruise and an enjoyable tea party was held. This though was frowned upon by the Chief Officer 'Taffy' Howell who managed the vessel in an exemplary fashion devoid of such things as tea parties.

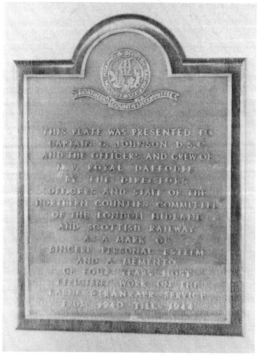

Plaque presented to Captain G. Johnson DSC and the *Royal Daffodil* by the directors of the LMS Railway and placed on the *Royal Daffodil* to mark her service from Larne to Stranraer (1940-44) during the Second World War.

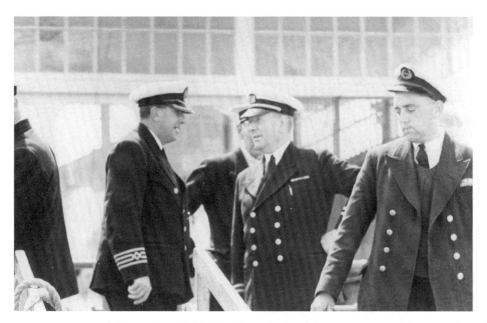

Captain Paterson of the *Royal Daffodil* (left) alongside the gangway at Margate Jetty around 1950.

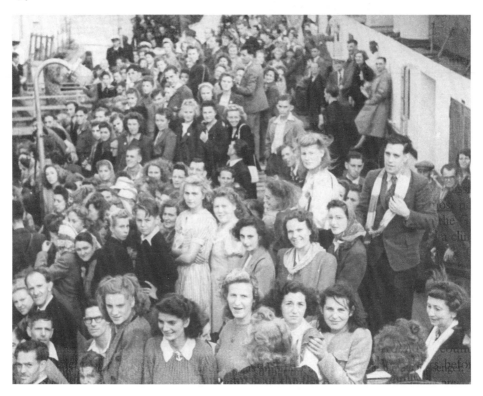

Happy crowds throng the deck of the *Royal Daffodil* in 1949.

Subject to alteration without notice R.D. PROGRAMME No. 2 : 1955

M.V. ROYAL DAFFODIL
or other vessel

GRAVESEND TO SOUTHEND
MARGATE & CRUISES TO THE
FRENCH COAST
(NOT LANDING—PASSPORTS NOT REQUIRED)

MONDAYS, TUESDAYS AND THURSDAYS
(except August Bank Holiday)

Until THURSDAY, SEPTEMBER 8th, 1955

MONS., TUES. & THURS. to view the French Coast, Cap Gris Nez—Boulogne or Calais

———— Leave ————		———— Return ————	
GRAVESEND (West Street)			
(Stuart Rd.) PIER	9.00 a.m.	MARGATE	5.30 p.m.
SOUTHEND	10.00 a.m.	SOUTHEND	7.30 p.m.
MARGATE	12.15 p.m.	GRAVESEND	8.30 p.m.

FARES
(Children under 14 half fare : Under 3 free)

GRAVESEND TO :

	SINGLE	PERIOD RETURN	DAY RETURN Mon., Tues., Thurs.
SOUTHEND	3/6	7/–	6/–
MARGATE	8/6	13/6	11/6

CHANNEL CRUISE FROM GRAVESEND 21/–

COMBINED TRAIN & FRENCH COAST CRUISE TICKET
Via GRAVESEND CENTRAL AND WEST STREET PIER

From	Train Departures Weekdays	Inclusive Fare (3rd Class Rail)
CHARING CROSS	7.43 a.m.	27/4
WATERLOO	7.44 a.m.	27/4
LONDON BRIDGE	7.48 a.m.	27/10
NEW CROSS	7.35 a.m.*	26/2
LEWISHAM	7.39 a.m.*	25/10
DARTFORD	8.16 a.m.*	23/2

* Change at Dartford.

Passengers return from Gravesend Central by any train same day.

From	Via MARGATE	Inclusive Fare (3rd Class Rail)
VICTORIA		28/–
BROMLEY SOUTH		25/9
CHATHAM	By all trains connecting	20/8
CANTERBURY WEST	with the steamer leaving	17/3
FAVERSHAM	Margate 12.15 p.m.	17/6
HERNE BAY		15/3
WHITSTABLE		16/–

Passengers return from Margate by any train same day.

FULLY LICENSED : RESTAURANT SERVICE AND LIGHT REFRESHMENTS

Royal Daffodil's programme of cruises from Gravesend during the 1955 season. This was the first year that the Government relaxed its restrictions on passengers travelling to France, enabling passengers to use identity cards with photographs instead of passports only.

Royal Sovereign departing from Margate during in 1952. At this time, she ran the service from Tower Pier to North Woolwich, Southend and Margate.

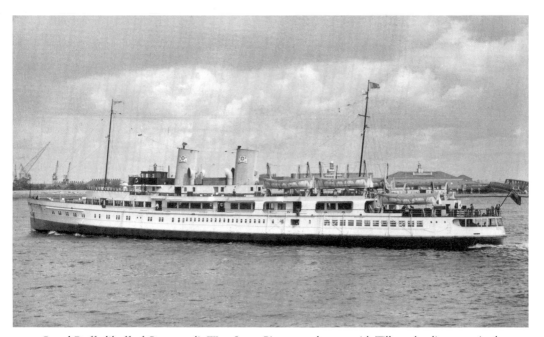

Royal Daffodil off of Gravesend's West Street Pier around 1959 with Tilbury landing stage in the background.

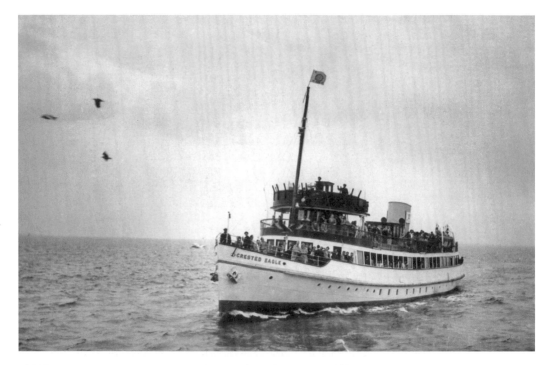

Crested Eagle approaching Southend Pier during the 1950s.

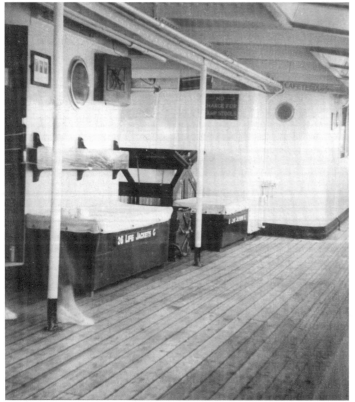

Aboard the *Crested Eagle* at Ramsgate in 1952. One of the *Crested Eagle*'s more unusual cruises was to deliver mail and newspapers to the Goodwin lightship on Monday and Thursday evenings at 7.00pm.

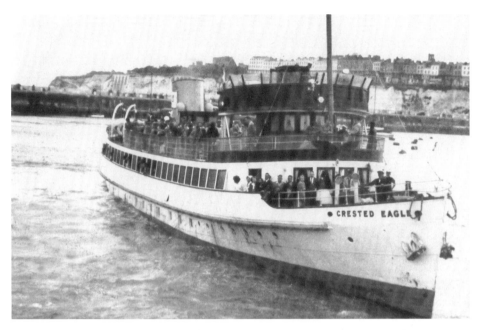

Crested Eagle arriving at Ramsgate. She had originally been purchased to retain the name *Crested Eagle* after the wartime loss of the famous paddle steamer but the opportunity to name a new and larger vessel never arose.

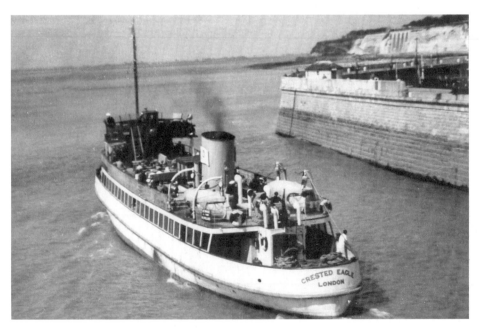

Crested Eagle departing from the East Pier at Ramsgate. On Mondays and Thursdays during the early 1950s her morning cruise was towards Deal and St Margarets Bay. Afterwards a 20-mile afternoon cruise towards Broadstairs, Margate and the North Foreland was undertaken.

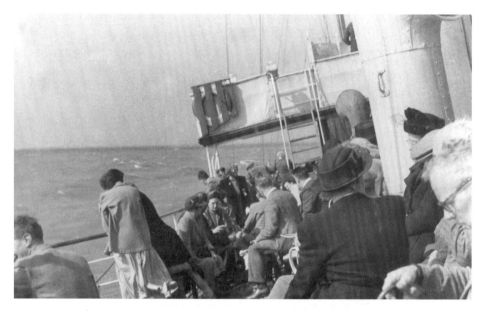

Passengers enjoying a lively cruise aboard the *Medway Queen* in 1959. In 1892, experiments by shallow-draft steamers led to the building of the pier at Herne Bay that lasted into the twentieth century. It was the second longest pier in the estuary, coming second to its rival resort of Southend. The most famous steamer associated with it was the *Medway Queen*.

Medway Queen alongside Strood Pier around the late 1950s. The Acorn Shipyard that was home to her owners can be seen on the opposite bank. Strood Pier became the regular calling point for *Kingswear Castle* in the 1980s and 1990s as well as occasionally being used by *Balmoral* in the 1990s. Strood Pier sadly became unusable for steamer services around ten years later.

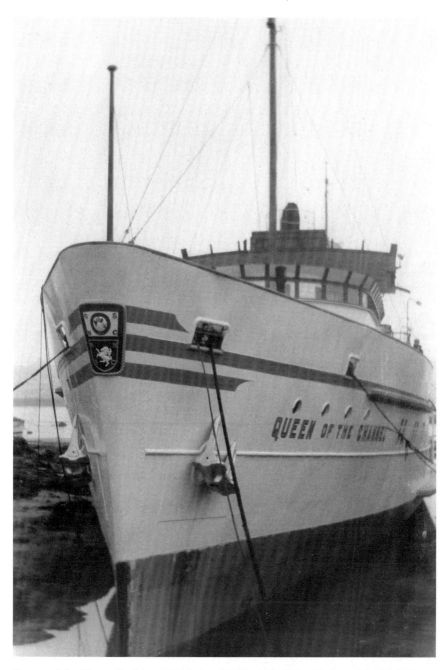

Queen of the Channel in her winter lay-up berth on the River Medway. The Medway was a regular place for the wintering of the GSNC motor ships. Note the pristine and newly painted hull above the water line. You can also appreciate the bow with its combined badge showing the GSNC and NMSPC emblems. *Queen of the Channel* was also laid up in the Medway at the cessation of services by GSNC in 1966 and remained there until being sold in February 1968.

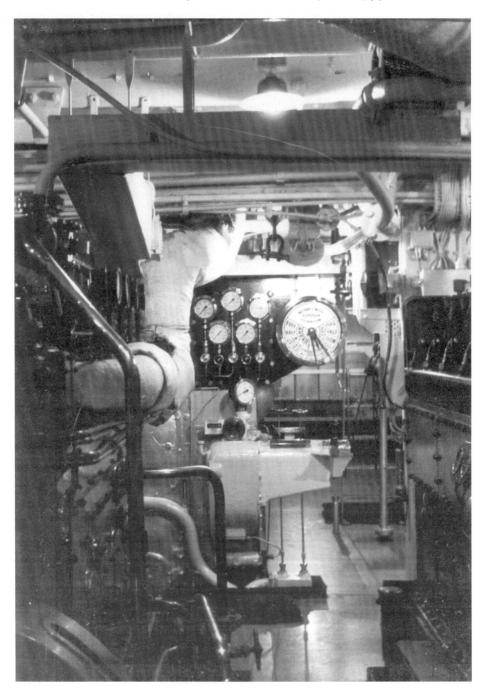

Engine Room of the *Queen of the Channel* in August 1958.

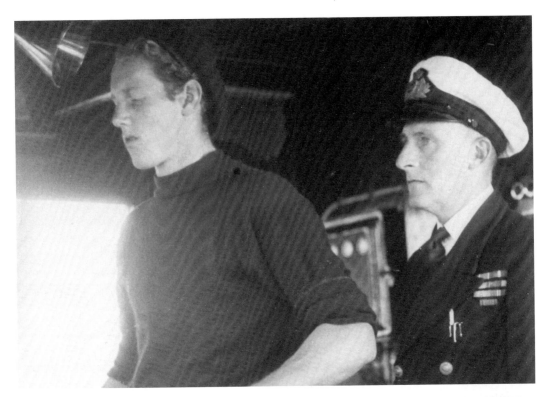

A view of the helmsman on a GSNC motor
ship during the early 1950s.

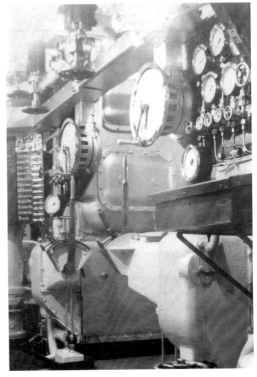

Engine controls aboard the *Queen of the
Channel* around 1955. She had a speed of up
to 18.5kt.

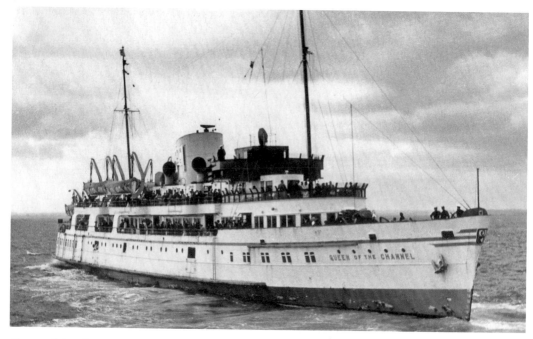

Queen of the Channel in July 1957. She had a capacity of 1,362 passengers and was well-loved for her cruises to Calais and Boulogne from Kentish resorts such as Ramsgate and Margate.

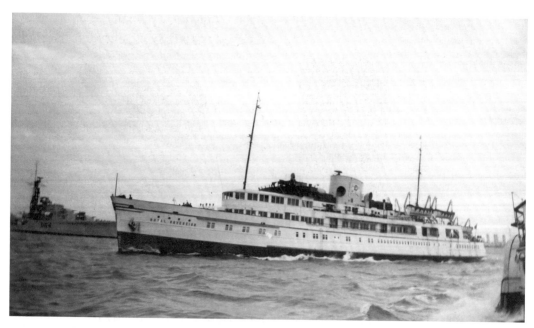

Royal Sovereign had been built by the famous company of William Denny of Dumbarton. She had Sulzer engines and could attain a speed of nineteen knots. She was 285ft 4in in length, 53ft wide and had a draught of 8ft 6in.

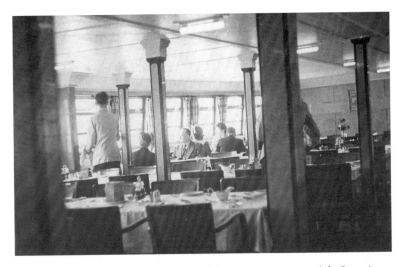

Working as a steward aboard the motor ships was never an easy job. Sometimes five sittings took place in the dining saloon of just 30 minutes for each sitting. After 20 minutes, a steward would ring a brass bell to warn diners that they had to finish their meal as the next sitting was due in 10 minutes. Stewards then hastily cleared and laid tables. This was all done in the days of silver service with silver-plate and linen tablecloths when appearance was important. Many of the catering crew were students or those just starting out in a career at sea.

The quiet first month or so of the season was used by GSNC to promote charter trade for the three motor ships. Many companies organised charters as a treat for their employees. De la Rue were a company that regularly organised charters. The recipe for success was quite simple; a fine ship with plenty of food and beverage outlets combined with a destination offering the same! This subscription card from the 1960s includes spaces on the reverse to record weekly payments towards the excursion.

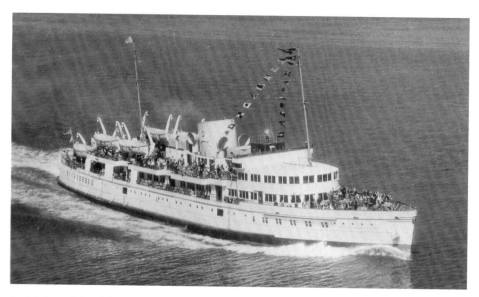

Aerial view of *Royal* Sovereign dressed with flags in the late 1950s. During the following decade she would be withdrawn after less than twenty years in service. She eventually became the longest-lasting of the Thames motor vessel fleet, finally departing to be scrapped in December 2007.

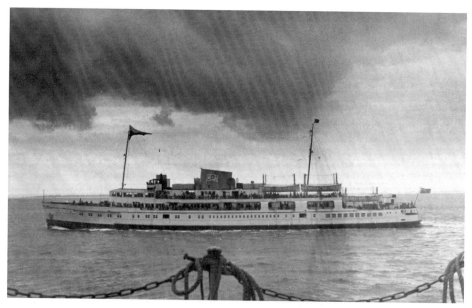

The three GSNC motor ships were often used for filming during the early years of mass television ownership in the 1950s and 1960s. For example, in May 1963, *Royal Sovereign* was used for filming an episode of 'Compact' starring Ronald Allen and Carmen Silvera. Later in the year the *Medway Queen* was chartered at Herne Bay on 30 May to appear in the film 'French Dressing' with Roy Kinnear. Shortly afterwards, on 16 June, a Jazz Festival was held with nineteen bands aboard the *Royal Daffodil* and *Royal Sovereign*. In addition, *Medway Queen* also appeared on a record sleeve for a record of party songs recorded by Bryan Johnston.

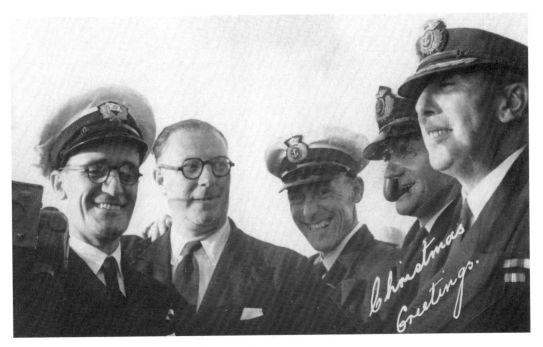

Officers pose for a Christmas card during the 1950s.

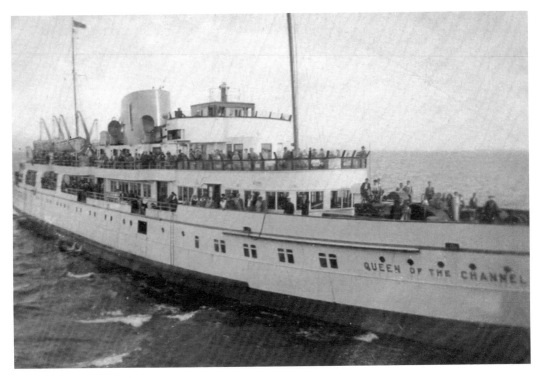

Queen of the Channel arriving at Southend on 3 July 1949.

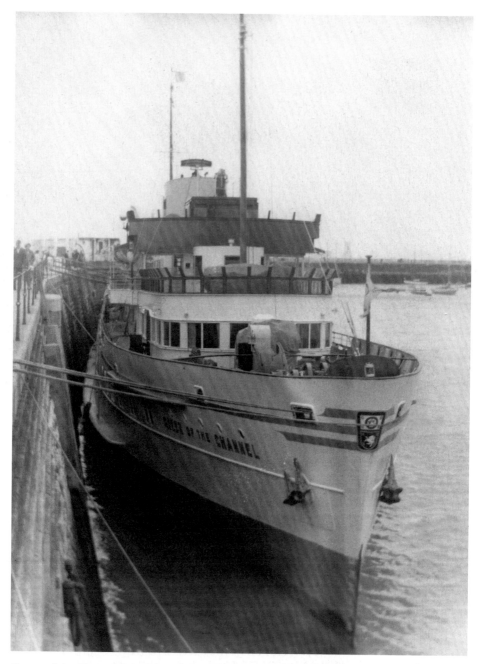

Queen of the Channel alongside the East Pier at Ramsgate, disembarking passengers from one of her regular cruises to France.

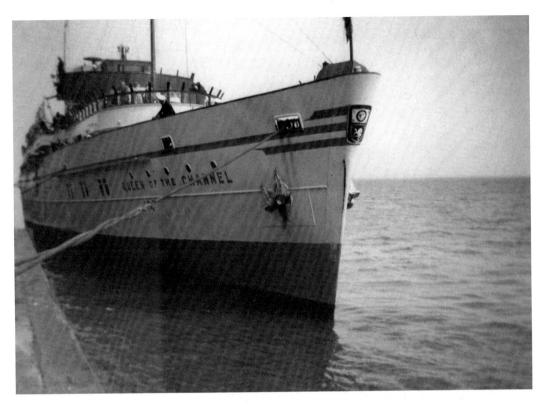

Queen of the Channel around 1955 at Southend Pier.

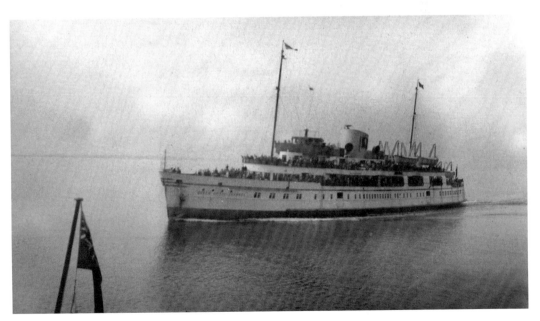

Queen of the Channel making her approach to Southend Pier on 25 August 1952.

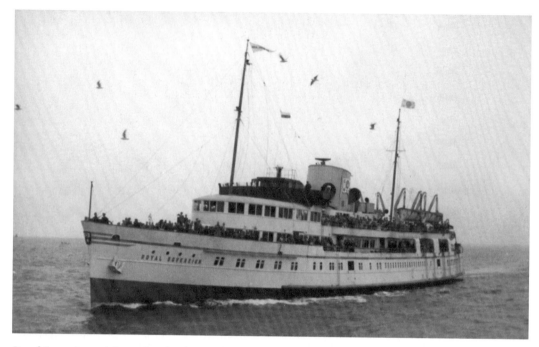

Royal Sovereign arriving at Southend Pier on 30 July 1950.

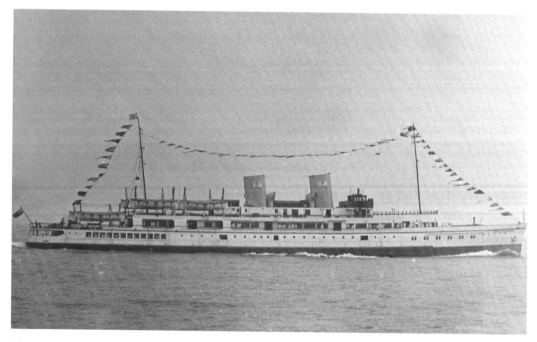

Along with the two other motor ships, *Royal Daffodil* finished the 1950s in a rapidly shrinking market. The first half of the 1960s would see the most dramatic change imaginable that would lead ultimately to their demise on the London River.

Chapter 3

Towards the End

Eagle Steamers entered the 1960s by offering services that followed a pretty standard pattern of sailings from London to Kent and Essex resorts as well as to the ever-popular Boulogne and Calais. Indeed, these services to the continent were flourishing with 61,300 passengers in 1957, 77,164 in 1959 and 78,031 in 1960. The building of a splendid new pier at Deal in Kent with purpose-built landing facilities further bolstered continental trade on the short hop to France.

But, the era of paddle and pleasure steamers was drawing to an end on the Thames and Medway; a fact mirrored in the rest of the UK when most steamers were lost during the first seven years of the 1960s. The writing on the wall was the withdrawal of the last paddle steamer *Medway Queen* in 1963. Amidst great emotion, this grand old veteran of Dunkirk made her final voyage from Herne Bay to Southend and back home to the River Medway. Just a few years earlier in November 1959, the Paddle Steamer Preservation Society had been formed to try and do its best to safeguard those paddle steamers that remained as well as educating the public on the heritage of this once vast steamer fleet. It did its best to save the *Medway Queen* as it did with so many other famous pleasure steamers, but its resources and effectiveness was somewhat limited during that preservation-starved decade.

Throughout 1963, 1964 and 1965, the three remaining steamers; *Royal Daffodil*, *Royal Sovereign* and *Queen of the Channel* gallantly sailed on. New initiatives were tried such as special jazz and music cruises to try and attract a younger clientele. Continental inclusive holidays to places such as Barcelona were offered by GSNC although only a small portion of the journey was by pleasure steamer. New embarkation points such as Great Yarmouth were also tried. Sadly, all of these initiatives were too little and too late to stop the decline into oblivion. A number of other operators also competed against the mighty GSNC, most notably the *Londoner* with its then exotic smorgasbord and bingo! On 20 December 1966, the announcement was made that services by the one invincible General Steam Navigation Company had ceased on the Thames and that the three remaining vessels were to be put up for sale.

But, pleasure steamers cruises on the Thames refused to die. A valliant attempt to run the ex-Firth of Clyde paddle steamer *Jeanie Deans* as the *Queen of the South* failed miserably after a disaster-prone short-lived career on the Thames. Other vessels such as *Consul*, *Ryde*, *Anzio* and *Queen of the Isles* made valiant attempts at introducing services but alas, these ventures were short-lived. By the end of the decade, there were no pleasure steamers left on London's great river and enthusiasts entered the 1970s with the once unthinkable thought that pleasure steamer services would never return again. For many, including people that owned the 1.5 million cars registered in London, the only way to the coast now would be by car, train or coach.

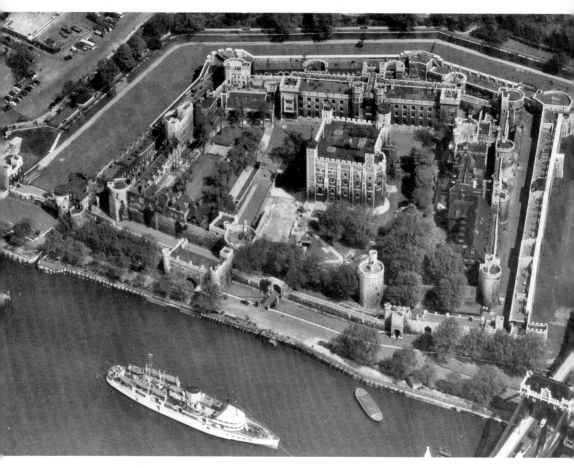

A rare aerial view of *Royal Sovereign* moored in front of the Tower of London. Tower Pier is on the left-hand side of the photograph. This mooring was frequently used by GSNC. Their impressive head office was situated behind the Tower of London in nearby Trinity Square.

Queen of the Channel moored at Boulogne with the distinctive modern blocks of flats in the background sometime during the early 1960s. The last motor pleasure steamer to visit Boulogne was *Balmoral* on a cruise from Eastbourne on 29 June 1996.

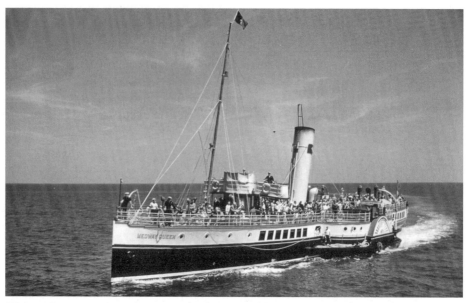

Medway Queen arriving at Herne Bay with Captain Leonard Horsham on 6 June 1962 towards the end of her career. The crew of the *Medway Queen* were famed for their smart appearance as can be seen from this photograph.

Medway Queen springing off of Strood Pier. After her withdrawal in September 1963, the Paddle Steamer Preservation Society held a public meeting on 18 October with a view to saving her. The meeting was favourably disposed towards this until it was learnt that her sale by the New Medway Company was subject to her not being placed in commercial service. Nonetheless, a '*Medway Queen* Trust' was formed with Don Rose as Treasurer with an initial aim of raising money to preserve her.

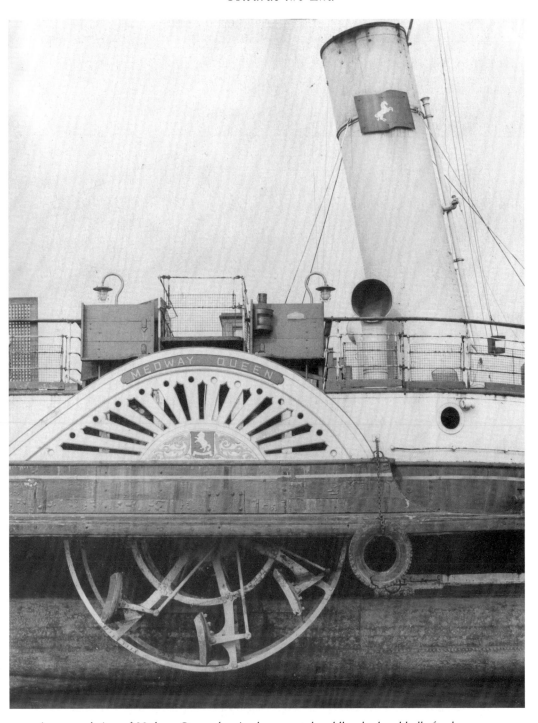

An unusual view of *Medway Queen* showing her exposed paddle wheel and hull after her withdrawal in September 1963. Her final cruise was on 8 September 1963 when she made her last trip back from Herne Bay. The emotion surrounding her withdrawal was intense.

Dining Saloon of the *Medway Queen* in 1962.

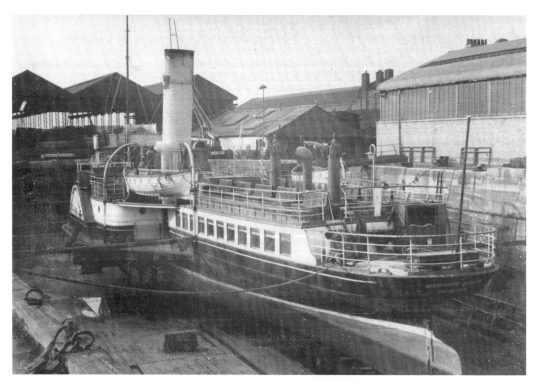

Medway Queen awaiting her fate at the Rotherhithe Dock in January 1964.

The bow section of the Promenade Deck aboard the *Medway Queen* in the East
India Dock in June 1964.

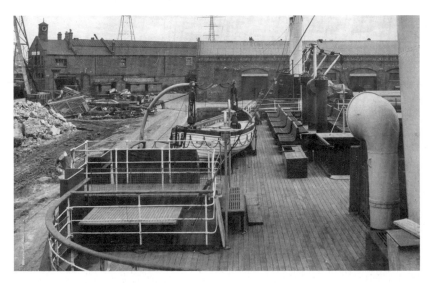

Medway Queen is shown here at the East India Dock in 1964 after her withdrawal
from service. In the following year she was sold by Forte to Van Heyghen Brothers
of Belgium for scrapping for a price reported to be £7,500 (Forte paid £2,300 for
her) as no berth could be found for her. This caused a fresh outbreak of publicity.
She was due to be towed away on 19 August but the breakers granted a last minute
reprieve. The Paddle Steamer Preservation Society and other bodies managed to
raise £6,000 to bid for the ship. *Medway Queen* then moved under tow to the Isle
of Wight for the next chapter of her story as the 'Medway Queen' Club'. The fight to
preserve her has now continued for almost fifty years.

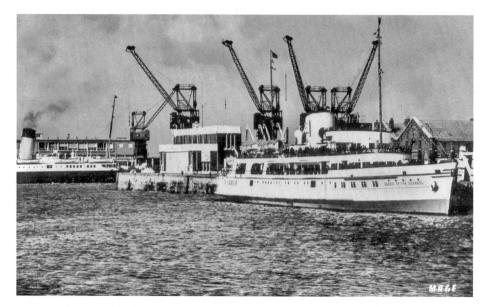

Queen of the Channel at Calais around 1960.

A familiar sight on a pleasure steamer then as now was the late passenger! During the 1964 season at Calais, a passenger forced his way onto the bridge of the *Royal Daffodil* as his friends had been left behind. In confusion he struck the First Officer and was subsequently fined £20 for trying to stop the ship. On 12 August that year there were more problems when two men broke into the exchange office on board and stole £600. Luckily the Chief Constable and a Detective Superintendant from Southend were aboard and all passengers were searched at Southend causing delays before the culprits were apprehended.

Queen of the Channel approaching Deal Pier during the early 1960s. The ship regularly undertook cruises to France from the pier during the 1960s but its fine new landing facilities were used for less than a decade due to the early demise of GSNC.

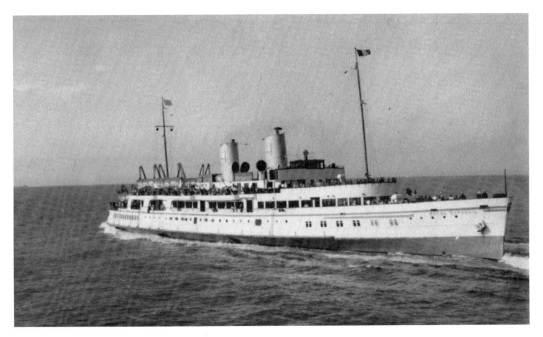

Royal Daffodil, arguably the most fondly remembered Thames pleasure steamer, departing from Calais on 17 October 1963.

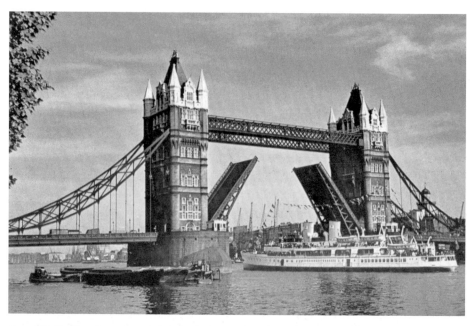

Royal Daffodil undertook popular 'Rock Across the Channel' cruises during the 1960s. On one occasion in 1961, the 'Shadows' joined the ship to play their pop classics on the way to France. Unfortunately, one member was confined to his cabin with seasickness for the entire trip! The last of these pop cruises took place in 1963.

Passengers crowding the deck of one of the motor pleasure steamers during the final years of operation on the River Thames. By 1964, *Royal Daffodil* and *Royal Sovereign* were running with 3,000 passengers to Southend most weekends.

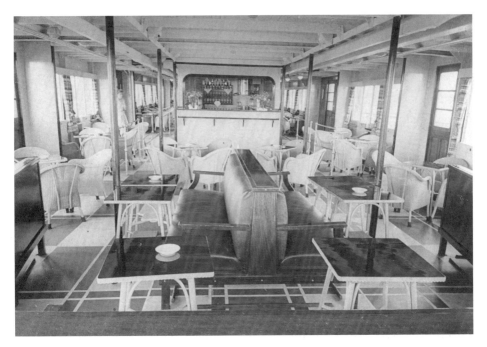

Lounge and Bar aboard the *Queen of the Channel* around 1960. The length and roominess of this covered accommodation can be appreciated in this view. Note the Lloyd Loom chairs and other fittings that were typical of that era.

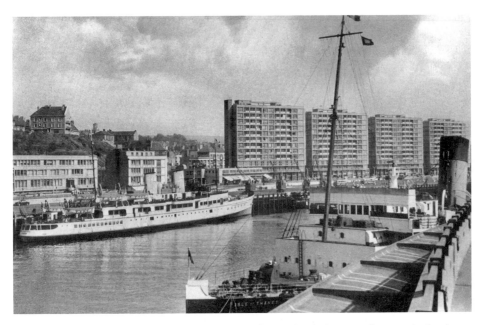

Royal Daffodil at Boulogne around 1960 with the ferry *Isle of Thanet* at the opposite berth. At the time, it was possible to travel to France for 38s 6d on a day return ticket with up to five hours ashore.

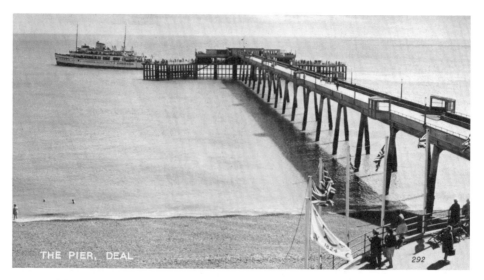

Queen of the Channel departing from Deal Pier around 1960. Deal Pier had been opened just three years earlier by HRH Prince Phillip on 19 November 1957. The pier was built with a three-tiered pier head for steamers to call at different states of the tide as can be seen clearly in this image. The lowest one was submerged for most of the time. The General Steam Navigation Company flag can be seen flying from one of the masts on the pier approach.

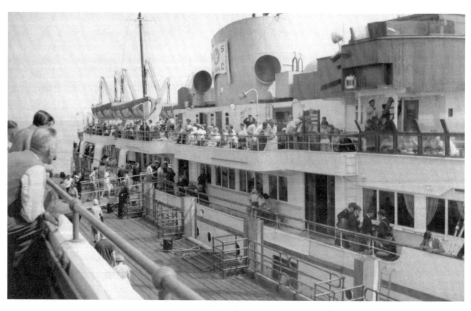

Queen of the Channel alongside Deal Pier during 1964 embarking passengers for a cruise to France. After her withdrawal, *Queen of the Channel* sailed from Sheerness bound for Greece and a new career as *Oia* (the name of a Greek island) on 5 March 1968. She sailed under the colours of John P. Katsoulakos. Before arriving at Sheerness she had been moved from her winter berth at Rochester to a mooring opposite Strood railway station until a week before she departed for Greece. A final indignity was the painting of a blue flag with a 'K' on it whilst still on the Medway.

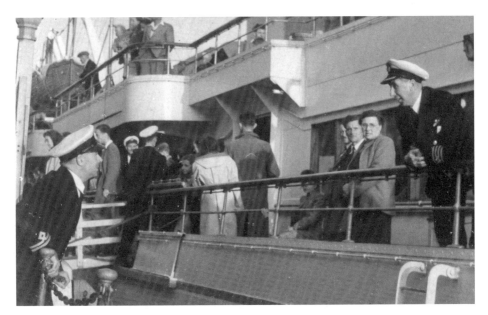

Captain Paterson will always be associated with the *Royal Daffodil*. Paterson remained with the summer service until ill health forced him to retire. Here he is seen in familiar pose aboard the steamer whilst disembarking passengers.

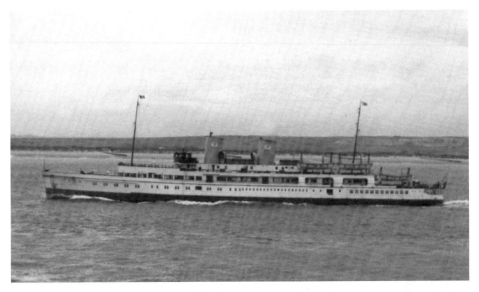

Royal Daffodil approaching Calais photographed from the ferry *Free Enterprise* on 10 September 1962. During 1966, the *Royal Daffodil's* season was extended by a week to 18 September. Her master was Captain Neil in succession to Captain Reynolds. Her season had started on 2 July and was badly affected by weather and strikes that resulted in the loss of many party bookings. The season was extended to take up many of the party bookings lost from the early season. To try and boost numbers, a pianist played in her lounge on her weekend cruises during 1966.

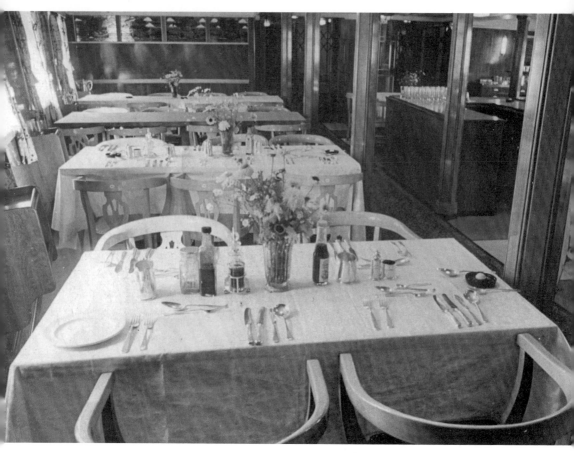

A corner of the Grill Room aboard the *Queen of the Channel* around 1960. 'Eagle Steamers' were famous for their cuisine and the ambience of restaurants aboard their vessels. Note the silverware and post-war style of this saloon.

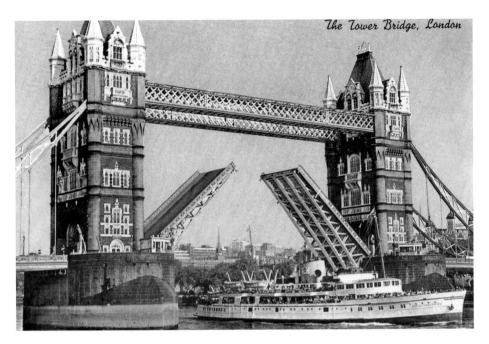

Royal Sovereign departing from London towards the end of her career.

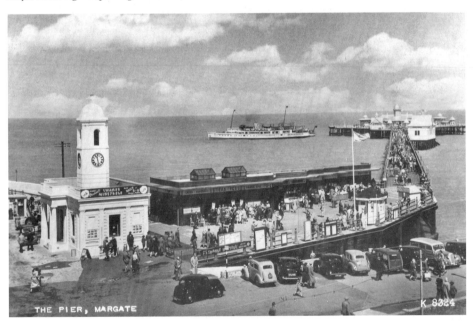

Royal Sovereign departing from Margate Jetty. Large crowds of passengers can be seen having just disembarked from the vessel. Margate Jetty was the first pier designed by Victorian pier supremo Eugenius Birch and was also the first iron pleasure pier to be built when it opened in 1855. It was a busy calling point for dozens of paddle and pleasure steamers until it was damaged by heavy storms in 1978. Pleasure steamer cruises still take place at Margate from the adjacent stone pier.

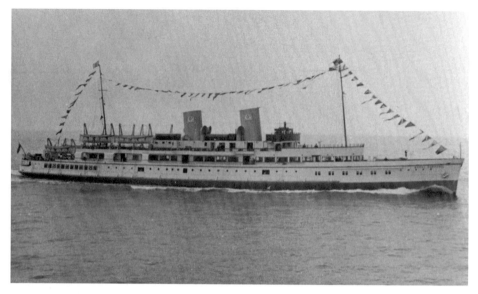

Royal Daffodil at sea in her heyday. Her sudden withdrawal from service was greeted with quiet resignation. Enthusiasts felt that although she faced the breakers, her two sisters might not suffer the same fate. She sailed on her final journey to the breakers in February 1967 witnessed by BBC cameras. Her two fleetmates did last longer although in significantly different roles. *Queen of the Channel* survived in Greece until 1984 whilst the *Royal Sovereign* survived until December 2007. Dreams of operating both as pleasure steamers after withdrawal by GSNC failed; *Royal Sovereign* by P&A Campbell and *Queen of the Channel* as a fleetmate for *Waverley* – a role eventually taken by Red Funnel's *Balmoral*.

A photograph titled 'When Day is Done and Shadows Fall' from 1961.

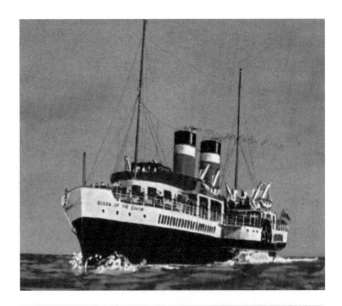

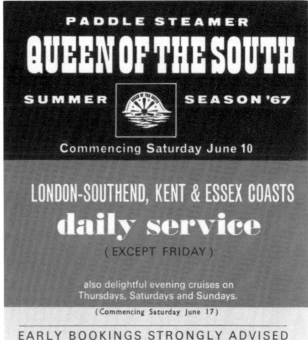

Between 1966 and 1967 there was a new paddle steamer on the River Thames – the ex-Clyde steamer *Jeanie Deans*, renamed as *Queen of the South*. Brochure for *Queen of the South* sailings on the Thames for the 1967 season. The brochure illustrates the fact that her owners really offered a quality product with a great deal for families and adults to do aboard the steamer. Dancing was offered and fun and games were arranged for children. A wide range of catering outlets

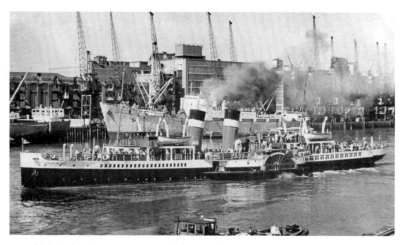

Queen of the South in the Pool of London. By the end of 1967, the costs resulting from the failure of the venture were mounting. The PLA claim alone was for £397 6s 10d for pier tolls, mooring charges and tonnage dues. Further charges were accruing at the rate of £10 0s 8d per day. At the time her scrap value was stated to be around £8,000. Her operating company had been wound up on 29 September. One last sad event was the death of her 1967 master, Captain George Fowle, who died following a heart attack on the steamer about a month before she left for the breakers whilst he was acting as watchman. One of her final duties was as a grandstand to view to arrival of Sir Francis Chichester aboard *Gypsy Moth IV* on 7 July 1967.

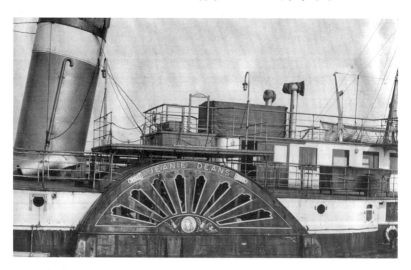

The end of the *Queen of the South* saga was marked by this notice in the personal column of the Times on 11 August 1966 – 'The directors thank all Thames lovers including the Port of London Authority, the Board of Trade, Trinity House, pier masters, Eagle Steamers and the PSPS for patience and assistance to this unlucky attempt to provide a public pleasure steamer service finally beaten by staff shortage'. *Queen of the South* is pictured here at Denton in 1966 prior to conversion and showing her original name of *Jeanie Deans*. It now looked like the era of pleasure steamer cruising on the Thames was drawing to a close.

Chapter 4

Phoenix from the Ashes

During the early 1970s, the number of paddle and pleasure steamers had dropped dramatically. On the Firth of Clyde in Scotland, the *Waverley* was being recognised for its uniqueness and was offered for preservation to the Paddle Steamer Preservation Society for just £1. *Waverley* initially cruised on the Firth of Clyde but by 1977 thoughts moved towards sailing her in waters far away from the Clyde. The Thames was a natural area for operating paddle steamer cruises and in 1978 *Waverley* proudly passed beneath the raised bascules of London's famous Tower Bridge for her first call at Tower Pier – her decks packed by her many supporters and crew. Who would have thought a decade earlier that a paddle steamer would once again grace London's great river.

During those early days the pleasure piers that had remained more or less empty for passenger traffic for over a decade, once again came to life. Southend Pier was the most popular for cruises from London as Margate Jetty had been destroyed shortly beforehand. Deal Pier also in those early years proved a popular calling point. In 1980, *Waverley* made one of her most poignant cruises ever as she went to the beaches of Dunkirk and the resting place of her predecessor. Her first master Captain John Cameron DSC laid a wreath to commemorate the loss of his former vessel.

Within a few years, a familiar and proven schedule of cruises were offered and the sight of *Waverley* on the Thames and Medway became a regular part of life on the river each year. In 1986, she was joined by the *Balmoral* a former Isle of Wight excursion vessel and ferry and has since shared regular cruises to familiar calling points of the old steamers such as Southend, Clacton, Great Yarmouth, Margate and Ramsgate.

By the early 1980s, the former River Dart paddle steamer *Kingswear Castle* was nearing the completion of her lengthy restoration on the River Medway. By late 1983 she was almost ready for passenger service and re-entered full passenger service in 1985 based at Chatham Historic Dockyard in Kent. *Kingswear Castle* operates primarily on the River Medway with occasional trips to London and the Thames.

The tradition of pleasure steamer cruises had evaporated during the 1960s on the Medway but *Kingswear Castle* with her undoubted charm coupled with good management and being in the right place at the right time has managed to show that there is a very real year-round market for pleasure steamer cruises on the Medway albeit for the right type of vessel. A highpoint to any season is the now traditional meeting on the River Medway at Upnor of the *Kingswear Castle* with *Waverley* during the 'Parade of Steam'. Then, the UK's last two operational paddle steamers celebrate their success and to show the world that these graceful old ladies still have a great deal of life in them. Pleasure steamer cruises on the Thames and Medway therefore still have a great future as long as we the passengers tread the gangways.

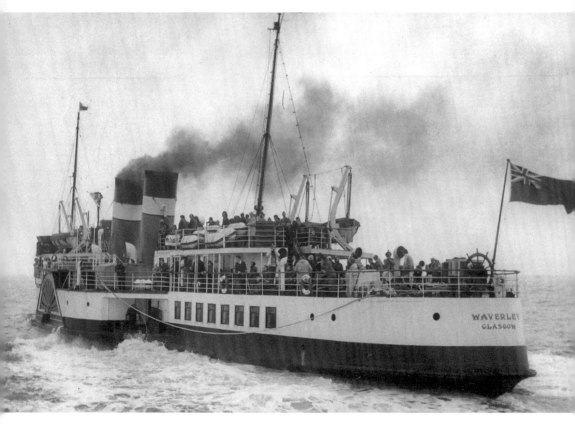

The legendary *Waverley* departs from Southend Pier on 30 April 1978.

Waverley arriving at Tilbury Landing Stage in 1980. Over the years *Waverley* and *Balmoral* have shared this berth for loading passengers along with many impressive ocean liners. The landing stage is also *Waverley* and *Balmoral's* home berth whilst based on the Thames.

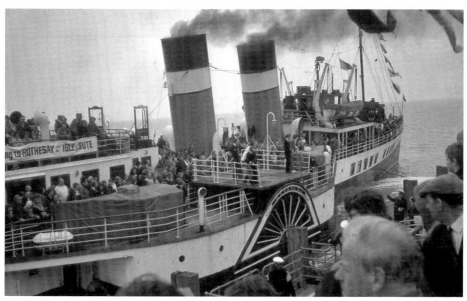

Waverley with a full complement of passengers arriving at Deal Pier in 1980. Sadly, due to the decline in landing facilities, Deal Pier was only used by *Waverley* for a couple of years. Deal offered the ideal destination for passengers and excellent numbers were carried to and from the resort. The pier was restored in 2007 but landing facilities remain closed to pleasure steamers.

A scene on *Waverley's* Promenade Deck around 1980 with her Chief Engineer Iain Muir and engine room crew member Davy Muir about to solve a problem.

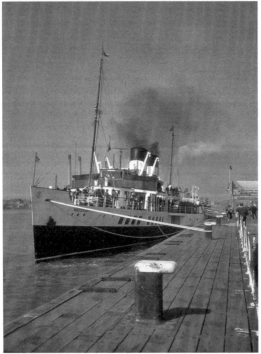

Left: Waverley alongside Tilbury during the early 1980s.

Passengers disembark from *Waverley* at Southend Pier around 1980. Southend Pier has always been vital to the success of pleasure steamers on the Thames and despite a series of fires and other catastrophes, *Waverley, Kingswear Castle* and *Balmoral* have managed to use the berthing facilities. The irrepressible Terry Sylvester – *Waverley*'s Commercial Director for many years – can be seen directing passengers at the top of the gangway.

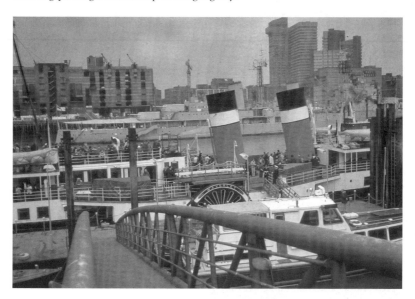

Waverley alongside Tower Pier around 1980 – a sight familiar to a generation of her passengers as they waited to join her for a trip to the sea. In the distance you can see the *Belfast* with many of the original dockside wharfes still in evidence. Just a few years later they were demolished and replaced by the Hays Galleria shopping and dining complex as well as the Mayor of London's headquarters at City Hall completed in July 2002.

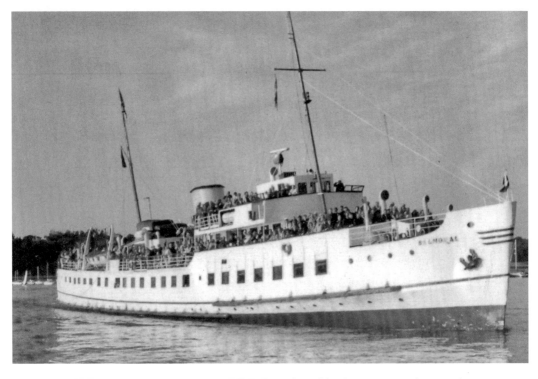

Balmoral has become a popular annual visitor to the Thames and Medway since her unplanned first visit in September 1987 to deputise for *Waverley*. It was one of the first examples of her role to deputise for *Waverley* in times of need thereby keeping the revenue and goodwill flowing. She is seen here on the River Medway off St Mary's Island during the parade in 1987.

A newly-restored *Kingswear Castle* meets *Waverley* for the first time on 9 September 1984 off St Mary's Island on the River Medway.

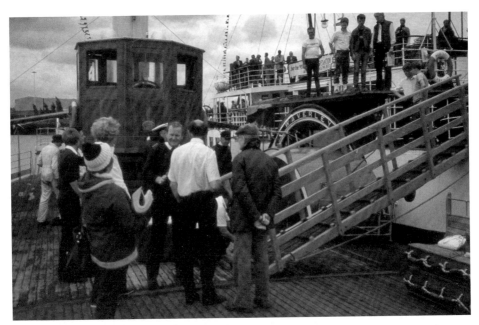

The *Waverley* tied up alongside *Kingswear Castle* on the River Medway around 1984. This was one of the earliest meetings of the UK's last two operational paddle steamers. Several prominent *Waverley* crew members can be seen including Captain David Neill, First Officer Steve Michel and John Lees. Enthusiasts prominent in *Kingswear Castle's* restoration are also shown including Pat Bushell.

Kingswear Castle on the River Medway at Rochester around 1984. During that season she could only carry a few passengers on her bare decks. In the distance is the *Medway Queen* on a barge just off Sun Pier at Chatham which was once a regular calling point for paddle steamers. The future of the *Medway Queen* was particularly uncertain at that time and she lay on this barge awaiting a berth for her planned restoration.

Passengers aboard the *Kingswear Castle* whilst she was alongside the Royal Terrace Pier at Gravesend during the 'Gravesham Edwardian Fair' in 1986. The fair was a popular regular event recreating Gravesend's Edwardian past complete with an Edwardian-style paddle steamer. The pier itself was the traditional landing place for royalty visiting London. Queen Alexandra (then Princess Alexandra of Denmark) first landed at this pier in 1863 to marry the future Edward VII.

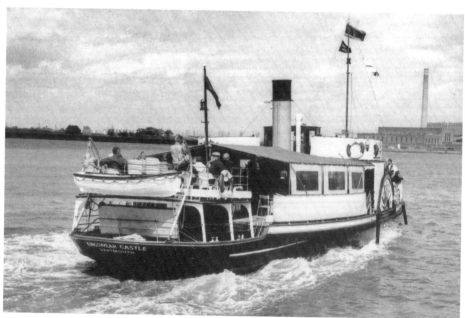

Kingswear Castle departing from Gravesend in 1992 with Tilbury Fort and the power station in the distance. The 1924-built *Kingswear Castle* has proved to be a perfect vessel for preservation and operation and her considerable success along with a perfectly balanced and profitable timetable has ensured that her future operation is ensured.

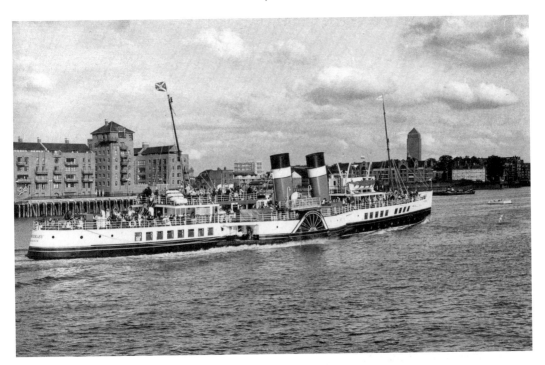

Waverley just after leaving the Upper Pool of
London on 8 October 1993. The Canary Wharf
Tower can be seen in the distance in the days
before it was joined by many similar structures.

A view of *Kingswear Castle's* paddle box and
wake during the 1985 season.

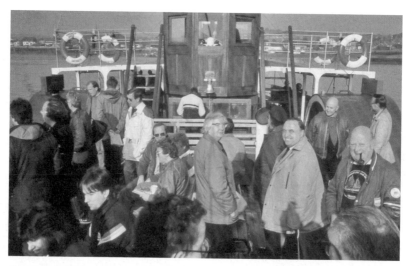

Kingswear Castle cruising on the River Medway in 1986 with many of her regular supporters aboard, including June Bushell, John Caldicot and Arthur Rickner. Since she re-entered full passenger service in 1985, *Kingswear Castle* has offered a wide range of longer day cruises to places such as the Thames Estuary, Southend, London, Snodland and the 'Whitstable Oyster Fair'. She has also offered a variety of short cruises that are ideal for families and those that just want a 'taster'.

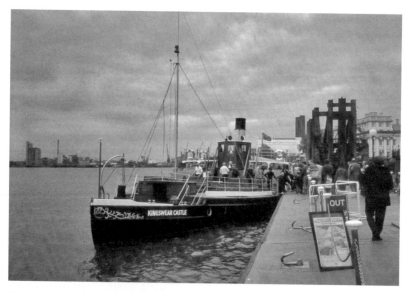

Kingswear Castle alongside Greenwich Pier around 1986 during her annual trip to London. Greenwich has occasionally been used by *Kingswear Castle*, *Waverley* and *Balmoral* but has never been a regular calling point. In recent years *Balmoral* has called at nearby Woolwich Dockyard Pier and both *Waverley* and *Balmoral* made several calls at the Millenium Dome Pier in 2000 to disembark passengers visiting the attraction.

Two enthusiastic *Kingswear Castle* supporters;
Patrick Taylor and Pat Bushell pictured
aboard the steamer around 1984 wearing their
Kingswear Castle T-shirts. Many volunteers
were involved with the lengthy restoration of
Kingswear Castle and both of these people
toiled with many others scraping and painting at
weekends to gradually restore the ship. Pat later
supplied administrative support to the steamer
during the early years of operation.

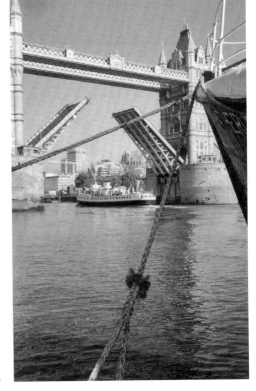

Balmoral passing under Tower Bridge viewed
from the southern shore around 2000. Some
of *Balmorals'* most fondly-remembered cruises
were in 1994 when she ran special cruises in
connection with the centenary of Tower Bridge –
the highlight being a spectacular firework display.

117

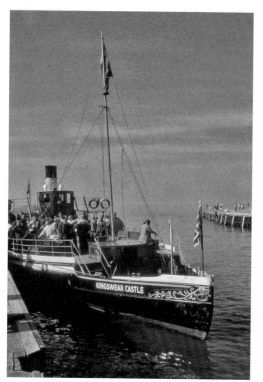

Kingswear Castle at Whitstable around 1986. A tradition for many years was the meeting of *Waverley* and *Kingswear Castle* at Whitstable each September. Passengers would often cruise to Whitstable by *Kingswear Castle* and then return to Tilbury or London by *Waverley*.

Waverley departing from Southend Pier on 30 April 1978. *Waverley* arrived at the pier for the first time just two years after the main structures on the pier head were destroyed by a massive fire in 1976. Restaurants, sun decks, shops, cafes and varied sideshows and amusements were lost at the time leaving *Waverley* to call for over thirty years at a pier head with very few facilities.

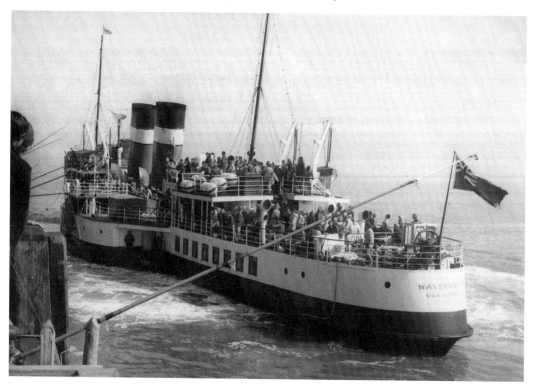

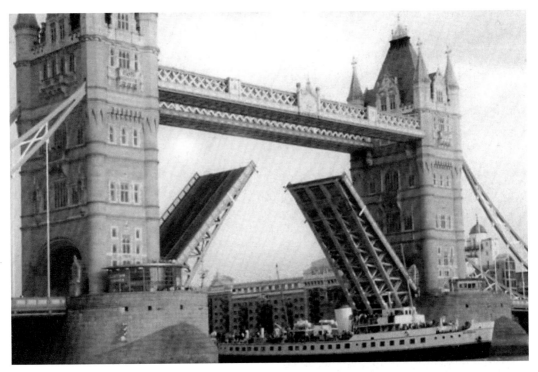

Balmoral passing under the raised bascules of Tower Bridge in 2000.

A distant view of *Waverley* alongside Tower Pier around 1985, viewed from the south bank.

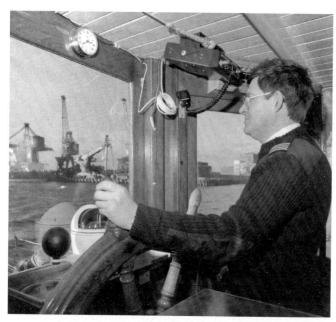

Captain John Megoran in the wheelhouse of *Kingswear Castle* around 1985. John Megoran grew up in Weymouth and became familiar with several famous paddle steamers such as *Consul*, *Embassy*, *Princess Elizabeth* and *Monarch* during their final years of service. He became *Kingswear Castle*'s Master and General Manager in 1985. The success of *Kingswear Castle* over the intervening years is largely due to his dedication, hard work and keen business sense.

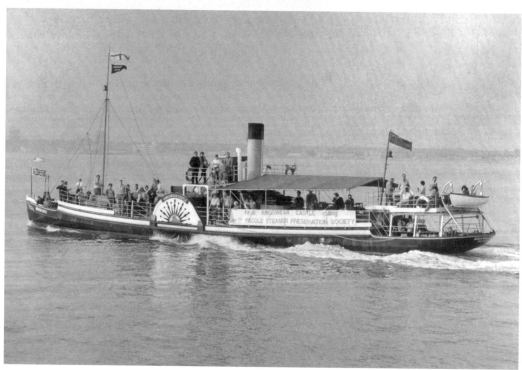

Kingswear Castle cruising off of the Essex coast at Thorpe Bay around 1987. During the first years of her preservation career *Kingswear Castle* offered cruises from Southend Pier. Initially she wasn't allowed to carry passengers across from the Medway to Southend but this changed after the first few seasons.

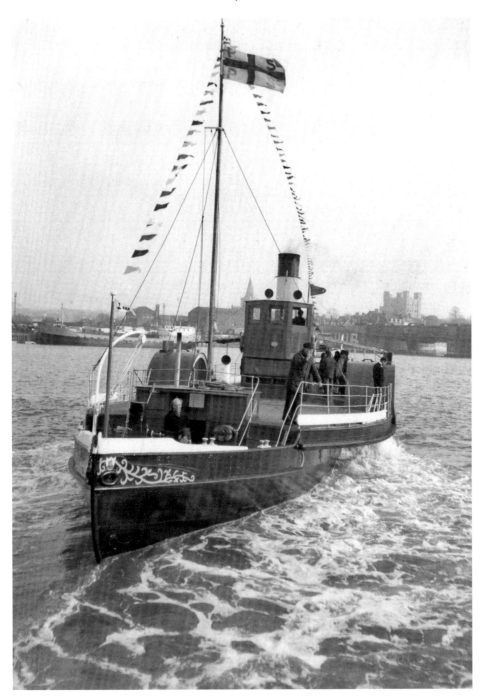

Kingswear Castle departing from Strood Pier around 1984 on her way to meet *Waverley* for one of the first 'Parades of Steam' on the River Medway. Note the spartan look of the deck without seating and the bridge wings that were added soon after.

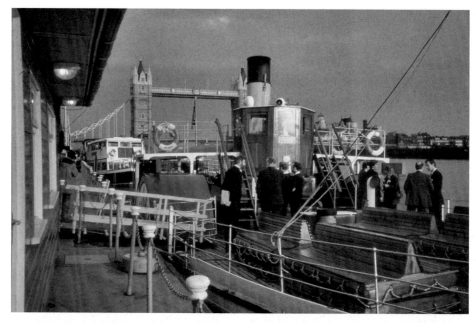

Kingswear Castle alongside Tower Pier at London around 1985. During the early years of her preservation career, *Kingswear Castle* gradually had her original features reinstated including the flying bridges seen in this photograph. These were a feature of her past career on the River Dart and allow passengers to embark and disembark at different stages of the tide.

Balmoral passing the now numerous blocks that surround the original Canary Wharf Tower in June 2008.

Waverley's paddle box in 2001. During the
early years of the twenty-first century *Waverley*
was extensively rebuilt with help from the
Heritage Lottery Fund to restore her to her
pristine 1947 appearance.

Waverley alongside Tower Pier with HMS
Belfast in the distance in May 1980. After
visiting the River Thames for over thirty years
now, *Waverley* has visited and operated on the
London River for more years than many of the
great GSNC paddle and pleasure steamers.

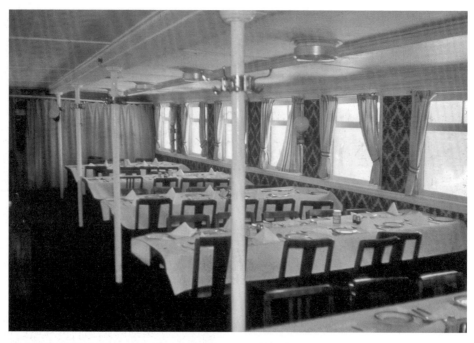

Waverley's Dining Saloon photographed at the time of her first visit to the Thames in 1978 during the final days before cafeteria service was introduced. During this first visit a wedding reception was held aboard *Waverley* and guests were entertained by the traditional Clyde steamer band.

Volunteer Joe Abrahams serving in the refreshment bar of *Kingswear Castle* in 1985. Many volunteers helped *Kingswear Castle* during her long restoration with several staying on to help operate her after she steamed again in 1983.

Right: Balmoral passing the Isle of Dogs
and Greenwich Peninsula in 2009. *Balmoral*
entered service in 1949 for service between
Southampton and Cowes for Red Funnel. She
was later acquired for further service on the
Bristol Channel for the White Funnel fleet. Her
white livery is that of the famous Bristol Channel
operators P&A Campbell.

Balmoral turning adjacent to London Bridge with
St Magnus the Martyr Church in the background
in 2003 as she prepares to take her passengers
back to Tilbury and Southend.

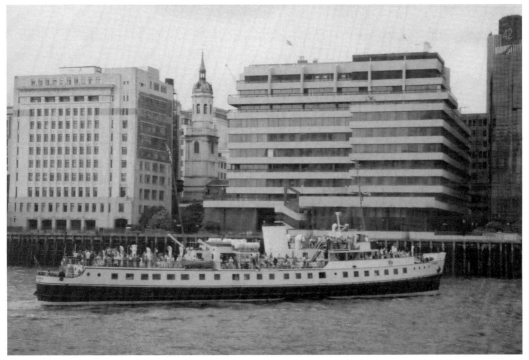

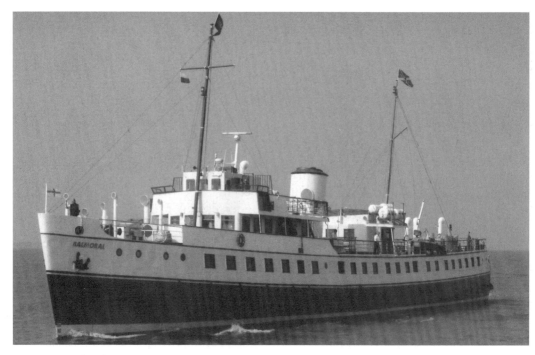

Balmoral arriving at Southend on Thursday 2 July 2009 for a cruise to Tilbury and London. *Balmoral*, along with *Waverley*, continues to use the traditional steamer calling points on the River Thames but they face an uphill battle as piers become derelict or unsafe. Southend is still a popular calling point to embark or disembark visitors. It will never though see the days when 278,655 passengers used the pleasure steamers at the pier in 1949!

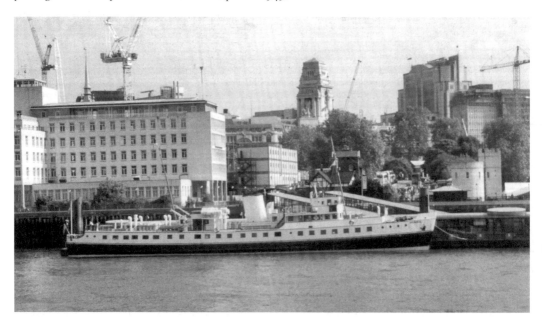

Balmoral alongside Tower Pier in 2004.

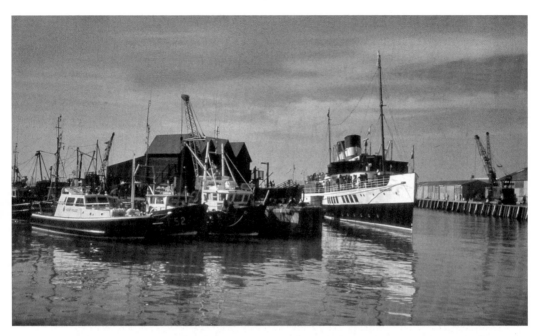

Waverley in the harbour at Whitstable around 1995. Whitstable is a very popular destination for pleasure steamers these days with its quaint harbour, seafood stalls and atmospheric high street. When the three present steamers arrive at the harbour there is always a flurry of excitement as passengers flood ashore to buy seafood before the journey back to Southend or London.

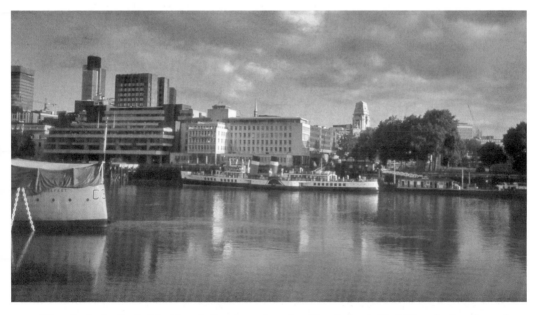

Waverley in the Pool of London during the early 1980s. The skyline behind *Waverley* has changed dramatically in recent years with new structures such as the Swiss Re Tower (more commonly known as the 'Gherkin') being the most dramatic new building on the London skyline.

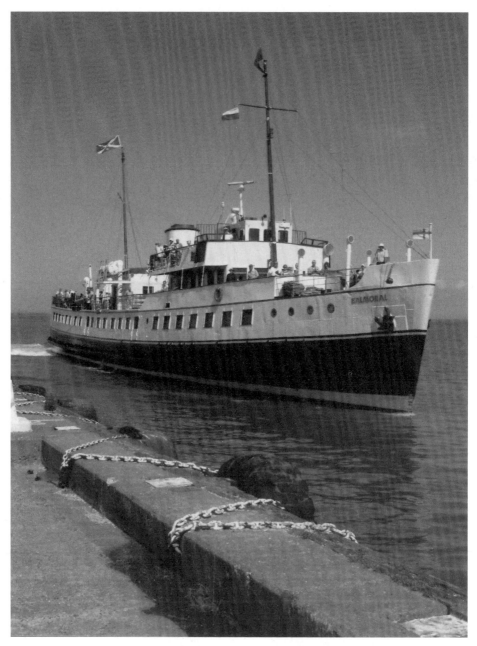

Balmoral arriving at the picturesque Kentish port of Whitstable on Saturday 4 July 2009. Just a week earlier she had celebrated her Diamond Jubilee with a special commemorative cruise from Southampton to Cowes and round the Isle of Wight – the routes for which she was built in 1949. The wonderful *Balmoral* carries on the great tradition that was the vision of Captain Sydney Shippick and his New Medway Steam Packet Company as she is the last of the great motor pleasure steamers. She also keeps alive the great and glorious tradition of coastal cruising on the London River along with *Waverley* and *Kingswear Castle*. Long may these three special and nostalgic ships continue!